IMAGES
of America

PINEDALE

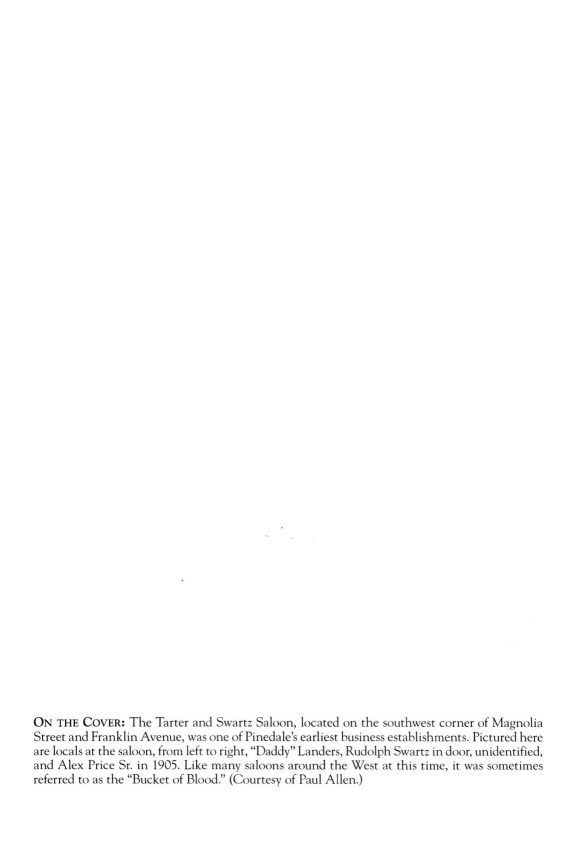

ON THE COVER: The Tarter and Swartz Saloon, located on the southwest corner of Magnolia Street and Franklin Avenue, was one of Pinedale's earliest business establishments. Pictured here are locals at the saloon, from left to right, "Daddy" Landers, Rudolph Swartz in door, unidentified, and Alex Price Sr. in 1905. Like many saloons around the West at this time, it was sometimes referred to as the "Bucket of Blood." (Courtesy of Paul Allen.)

IMAGES
of America

PINEDALE

Ann Chambers Noble

Enjoy!

Ann Chambers Noble

ARCADIA
PUBLISHING

Published by Arcadia Publishing
Charleston, South Carolina

Printed in the United States of America

Library of Congress Catalog Card Number: 2008926271

For all general information contact Arcadia Publishing at:
Telephone 843-853-2070
Fax 843-853-0044
E-mail sales@arcadiapublishing.com
For customer service and orders:
Toll-Free 1-888-313-2665

Visit us on the Internet at www.arcadiapublishing.com

*To the "old-timers" in Pinedale who continue to help me document
the area's history, and to my husband, David, my best editor.*

CONTENTS

Acknowledgments

Photographs in this volume were gathered from a variety of sources, including the Sublette County Historical Society. Thanks to Laurie Hartwig and Millie Pape for help with this collection and Clint Gilchrist, who gathered many of these photographs on behalf of the Sublette County Historic Preservation Board. I am also thankful to the families who dug through trunks, cabinets, and closets to share their personal albums. These include Jack Doyle with the Thurston and Leita Doyle photographs, Ralph and Charlotte Faler, Paul and Bette Hagenstein, Dorothy and Cindy Noble, Ruth Noble, Pat and Ben Pearson, Tom and Shiree Prather, Ruth Shriver, Erma Steele Shriver, Mary Ellen Steele, and Dave Takacs. Special thanks to Sue Sommers for her help with scanning and, particularly, editorial assistance. And to my husband, David, for his continued support with my history projects.

INTRODUCTION

John F. Patterson, known as the founder of Pinedale, proposed establishing a town in the Green River Valley along Pine Creek in western Wyoming. He offered to build and stock a general store if local ranchers Charles A. Petersen and Robert O. Graham each donated five acres for the town site. The three gentlemen agreed to this plan, a surveyor was hired, and the town of Pinedale, named after the post office on Petersen's ranch, became a town on paper owned by these three men. The ranchers' property line would become Pine Street. Founders Day was September 26, 1904, when the first town plat was drawn on a piece of yellow cloth, showing blocks, lots, and streets. Free town lots were offered to early settlers, one of whom was C. Watt Brandon, John Patterson's nephew. Brandon built a newspaper office for his paper, the *Pinedale Roundup,* which also housed the new post office. More than 100 years later, the newspaper is still in print.

The tiny town provided important services for small yet thriving industries in the area. This included supplying provisions for the early "tie hacks" living in mountain camps. "Tie hacks," the men who cut the trees and shaped railroad ties from them, came from around the world for this work. The Union Pacific Railroad expanded its tracks through Wyoming in the early years of the 20th century, creating a demand for ties to support the new rails. The ties came from pine trees in the mountains surrounding Pinedale that were cut and hewn before being floated down the flooded springtime mountain streams to Green River, Wyoming, where they were initially gathered before being sent to the working railhead.

Tourism has always been a source of economic support for Pinedale. Even before Pinedale was founded, "dudes," or guests, paid to be assisted in visiting the mountains. From the late 1800s to the present, tourists have come to enjoy horse-pack trips, fishing, and hunting in the beautiful mountains surrounding Pinedale. The town also became a destination, creating a demand for hotels and later motels. As the town celebrated its heritage with parades, rodeos, and Rendezvous, visitors were often included.

Cattle ranching has long supported Pinedale. Great herds of Herefords and Black Angus have roamed the Green River Valley on area ranches, some established before Pinedale. Ranchers and cowboys, along with their families, were among the early settlers of the town. They have long been the pillars of the community, supporting the town economically, socially, and politically.

In 1912, Pinedale was incorporated, gaining the popular claim to fame as being the farthest incorporated town from a railroad in the United States. It is nearly 110 miles to Rock Springs, Wyoming, the closest railroad. Ripley's Believe It or Not apparently checked it out and found it accurate. It became a slogan for the town for decades, used on town letterhead and tourist information, as well as the front-page flag for the *Pinedale Roundup.*

Despite the community's isolation, its locals have always been connected to world events. When the United States entered the World War I in 1917, Pinedale's young men volunteered to serve in France with the Machine Gun Company, 3rd Wyoming Infantry. Two Pinedale servicemen lost their lives in France in that war. The body of Sidney Edwards was brought back to Pinedale and reinterred in the Pinedale Cemetery in August 1921. Clifford Phillips remains buried in France. The town's American Legion Post 47 is named in honor of Phillips and Edwards.

With help from World War I veterans, Pinedale slowly grew into a community during the 1920s. The town council concerned itself with building streets and sidewalks throughout the decade. Once they were built, the council solicited townspeople to assist in planting trees along the streets, then keeping them watered. Lighting the streets was also a priority at this time, made possible by a small electric light plant. The town nearly doubled in size as new stores, hotels, and other businesses were built along with modest homes. A big victory for the area came in February 1921, when Sublette County was formed via a bill passed by the Wyoming State Legislature and signed by Gov. Robert Carey. A few months later, Pinedale was chosen as the county seat in a heated and controversial election that created hard feelings with the other town in the new county, Big Piney.

A decade later, the town was impacted by economic hard times brought on by the Great Depression of the 1930s. Pres. Franklin D. Roosevelt's New Deal programs helped the community when federal aid came with the Civil Works Administration. This program assisted with work on Pinedale streets and the construction of a storage dam near Fremont Lake, approximately three miles north of Pinedale. Additional aid came when the Works Progress Administration provided funds that constructed and improved the water and sewer system, developed the airport, and supplied the labor for a new brick schoolhouse. The largest federal New Deal program in the area was a Civilian Conservation Corps (CCC) camp built on the south shores of Fremont Lake. Several young men from the local area worked at the CCC camp, but their numbers were small compared to the hundreds brought in from around the country.

Pinedale was again directly impacted by world events when the nation went to war in December 1941. World War II was felt close to home, and the townspeople raised money through war bonds, collected materials for recycling, and took war precautions. Young men, and some women, from Pinedale and the surrounding area joined the military services in great numbers and fought for their country around the world. Two young Pinedale men lost their lives in this war. S.Sgt. Ralph Wenz lost his life in Alaska when his bomber crashed on December 21, 1943, and S.Sgt. Boyd Skinner was killed in action at Iwo Jima on March 10, 1945. In the morning of Memorial Day 1949, the Pinedale airport was formally dedicated as the Ralph Wenz Field, while in the afternoon, the town park was dedicated as the Boyd Skinner Park after the fallen veterans.

The postwar boom enjoyed throughout the country in the 1950s was also experienced in Pinedale. During this decade, the town again improved its infrastructure, renovated some of the streets and sidewalks, and expanded the fire department. Private industry also contributed to the town's growth at this time. Telephones were converted to the dial system in 1955; and after a tragic fire, the electric plant was expanded and improved. The electric company also brought television in 1957. The highways were open year-round for the first time, resulting in an expanded Pinedale school district as more of the surrounding rural school districts closed and sent their children to Pinedale. The highways were not traveled extensively, especially in the winter; but rather, the community looked to itself for its needs. The town established its first public medical clinic, built a new high school, added kindergarten to the elementary school, and initiated a county library during the 1950s. The community also built an outdoor swimming pool and ice-skating rink.

The post–World War II era is also referred to as the cold war, a time when the United States was involved in "police actions" around the world, notably in Korea and Vietnam. Young men from Pinedale again put on military uniforms and answered their country's call to serve. Paying the ultimate price was Mike Wilson, a Pinedale High School graduate from the class of 1968. He was killed in action in Vietnam in June 1969. His final resting place is the Pinedale Cemetery.

The 1960s will long be remembered in the United States as a time of social unrest and transition. Voices for social and political change were heard in Pinedale but did not seem to impact those making a living from the land and the limited economy of Sublette County. Pinedale streets were not the setting for protests and marches, but rather continued to be used for cattle drives, homecoming parades, and raceways for chariot and cutter races.

Throughout its history, Pinedale citizens have always worked and played hard. Hundreds of people turned out to participate in or to watch rodeos, parades, chariot races, ski-joring, dogsled

races, and other events sponsored at the summer and winter carnivals. Nearby Fremont Lake has always been a popular gathering place for Pinedale citizens to relax and enjoy themselves. The deep-blue glacial lake has drawn folks for picnics, boating, water-skiing, and, of course, fishing, even in wintertime. Early photographs of picnickers are often set at Fremont Lake—on the ice and snow. Ice fishing has been popular, despite the subzero weather known for most of the winter months.

Another popular gathering spot for the townspeople has been the local ski hill, White Pine. Located about 12 miles from town, White Pine was built on Fortification Mountain at Surveyor Park. In September 1939, a cable tow arrived and, by the first snows, was operating, taking skiers up the hill. The CCC workers further expanded the resort by clearing runs and then using the logs to build a lodge. Potluck dinners were hosted for years in this lodge by the locals, who enjoyed their meals after a few runs on the ski hill.

Pinedale has long had a sense of its own unique history and heritage, and has found special ways to celebrate it. One especially important commemoration is Rendezvous, beginning in 1936 and held every July, when the community reenacts the early fur-trade era between Native Americans and fur-trading companies. The original Rendezvous of the 1830s were held near Pinedale. Activities during Rendezvous include rodeos, parades, and picnics. While enjoyed by the locals, Rendezvous has also been an important tourist attraction.

Pinedale has always experienced relatively small growth. It is a community that economically survived throughout the first half of the 20th century by supporting industry in the area, especially agriculture and tourism. The town's fierce isolation created hardy and independent citizens who were forced to be self-sufficient. Self-reliant Pinedale citizens took care of themselves and one another. Despite the isolation, though, Pinedale people have always served their country when called. People who have survived here were the true rugged individuals identified with the American West, who were also outstanding American citizens.

The Pinedale of the past, though, began to change profoundly starting in the late 1990s, with the exploration and mining of natural gas in giant gas fields south of town. The community grapples with rapid change, especially with the influx of new people into Pinedale and the surrounding area who are trying to take advantage of the numerous jobs made available by minerals extraction. Perhaps that is why there is a growing appreciation and an occasional yearning for how life was in Pinedale during its isolated, quiet years during the first half of its history.

One

THE EARLY YEARS

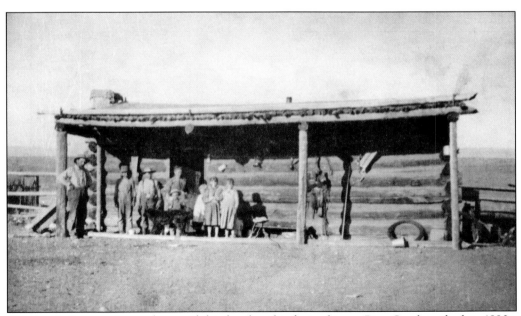

Charles A. Petersen is seen here with his family at his first cabin on Pine Creek in the late 1890s. He would later donate five acres of his ranch land to help create the town of Pinedale. The family's last two children, of eight, were born on this ranch. Petersen claimed he had the first baby in the town, though it was before Founder's Day and south of the town site. (Courtesy of Sublette County Historical Society.)

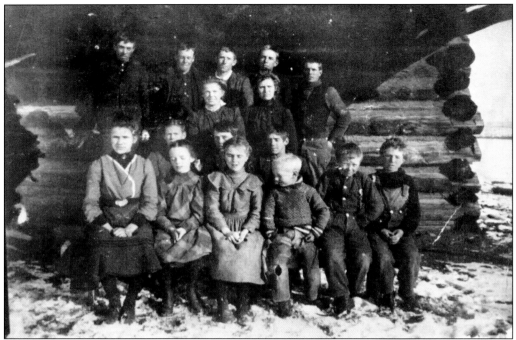

Children pose for a school picture at the Charles A. Petersen ranch in 1903. Children attending this school were from the Cantlin, Bloom, Bayer, Allen, Sweeney, and Petersen families. Frank E. McGrew, not pictured, was their teacher. McGrew, referred to by the locals as "Professor," became the first teacher in Pinedale when the town built its first school in 1904. (Courtesy of Paul Allen.)

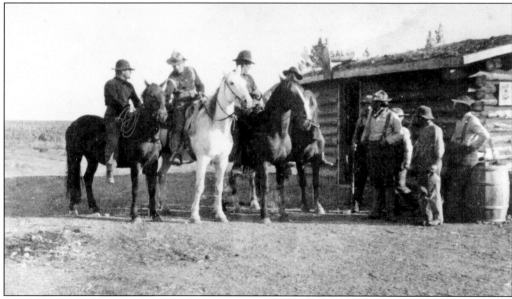

Pinedale's first saloon was located on the Petersen ranch, pictured here. The large man standing is Charles Petersen. This was the original building that housed the first Pinedale Post Office, until Petersen went into the saloon business; at which time he had the post office turned over to Celia Graham, who took the office into her home. (Courtesy of Sublette County Historical Society.)

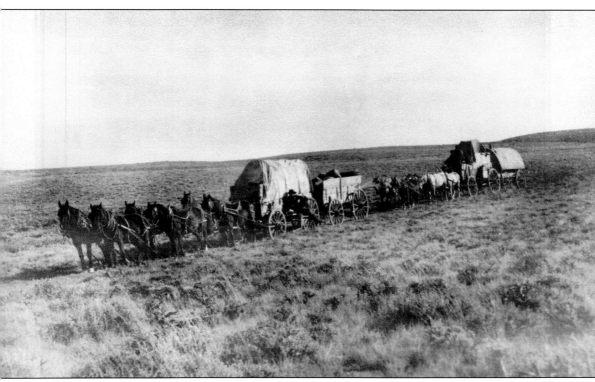

These freight wagons to Pinedale began their trip in Rock Springs, Wyoming, the nearest railhead town, located 100 miles away. Four and six horses are pulling these wagons. Larger freight wagons often used 12 horses pulling four wagons at a time with loads up to 20,000 pounds. This was the only available means to bring supplies to Pinedale in the early 1900s. (Courtesy of Sublette County Historical Society.)

Boots Williams stands on the left next to an unidentified man in front of Pinedale's first building, the Franklin Mercantile Company, owned by John F. Patterson, the town's founder. The photograph was taken in 1905, when the town was only a year old. (Courtesy of Sublette County Historical Society.)

C. Watt and Mayme Brandon stand in front of their Pinedale Roundup Building on July 4, 1905. Brandon came to Pinedale at the request of his uncle, John Patterson, to start a newspaper. The first issue of his paper, the *Pinedale Roundup*, rolled off the press on September 8, 1904, a few weeks before the town's Founder's Day. (Courtesy of Sublette County Historical Society.)

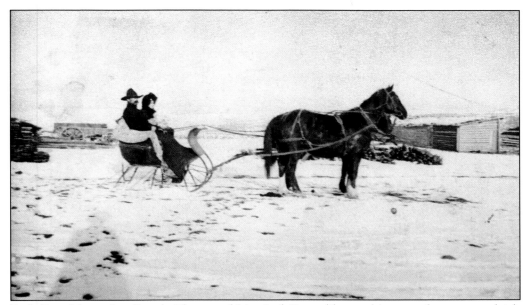

Early Pinedale settlers Bunch Glover and Mrs. Jack Reynolds travel in a two-horse open sleigh in the early 1900s. Because of the long winters, sleighs were a necessary form of transportation. (Courtesy of Sublette County Historical Society.)

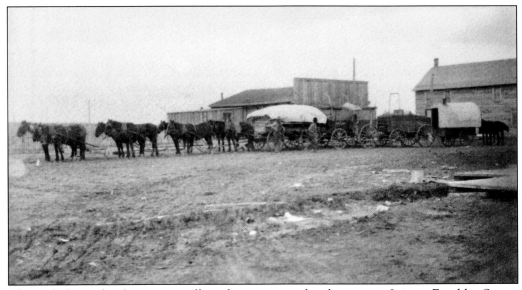

This eight-horse freight train is pulling three wagons plus the cooster. It is on Franklin Street, in front of the Pinedale Roundup Building and the Woodman Hall, about 1908. The freighter's "home on the road" was the cooster, set up much like a sheepherder's wagon. A trip from Rock Springs to Pinedale usually took two weeks, weather and floods cooperating! (Courtesy of Sublette County Historical Society.)

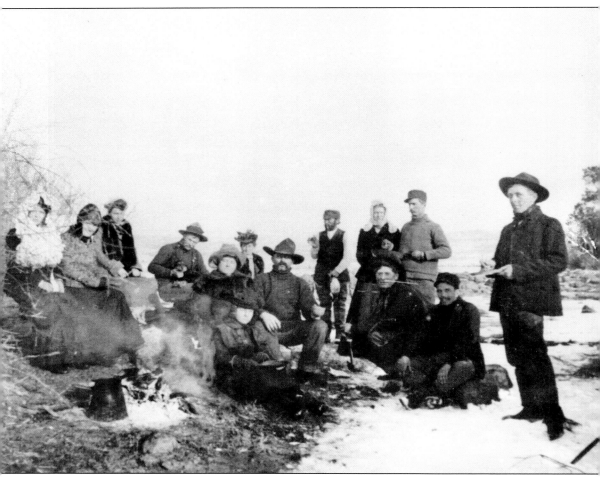

Fremont Lake was a popular gathering place year-round. This group of Pinedale locals was fishing and picnicking on January 17, 1904. From left to right are Elsie Winn Faler (Mrs. Ralph Faler), a Mrs. Winn, Beulah Montrose, Phil Burch, Nettie Hoff, Jennie Faler, Alice Montrose, Bunch Glover, Dr. J. W. Montrose, Lena Edmunson, Bert Clark Sr., Lee Edmunson, Frank McGrew, and Ralph Faler. (Courtesy of Sublette County Historical Society.)

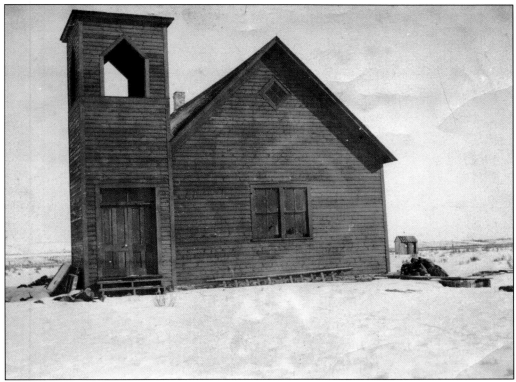

On July 17, 1910, a Community Church building was dedicated on the corner of Mill Street and Maybel Avenue, facing west on land donated by John F. and Maybel Patterson. The Congregationalists were largely the builders of this church, but it was initially dedicated as a Community Church to be used by different denominations. (Courtesy of Ellen Cole.)

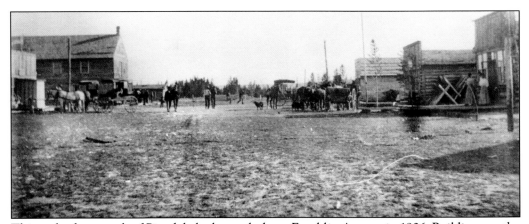

This early photograph of Pinedale looks south down Franklin Avenue in 1906. Buildings on the left (east) side of the street are the Pinedale Roundup Building and post office, Woodman Hall (the first two-story building in town), and the schoolhouse. On the west side, from left to right, are Sturdevant's drugstore, Franklin Mercantile Company or Patterson Store, and the Patterson home. (Courtesy of Paul Allen.)

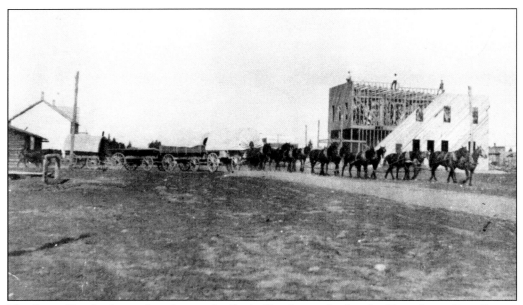

The Pines Hotel, often referred to as the Fardy Hotel, was the first building facing Pine Street. Under construction here in 1913, it is pictured with a typical "freight train" of the early 20th century pulling onto the street. (Courtesy of Sublette County Historical Society.)

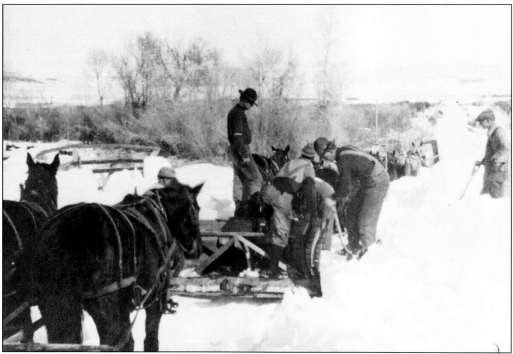

Winters are long in Pinedale. Battling subzero temperatures and heavy snows are a way of life. Pictured here are early settlers clearing spring snows on the road to Pinedale from Rock Springs. Prior to World War II, Pinedale residents were isolated in the community throughout most of the winter. (Courtesy of Sublette County Historical Society.)

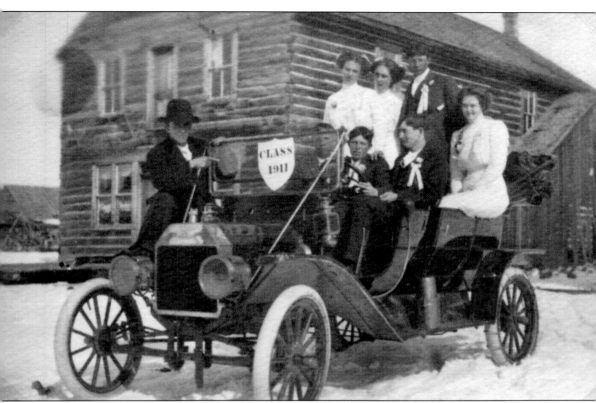

Until 1919, eighth grade was the highest level taught at the Pinedale School. This photograph shows the first eighth-grade graduating class in front of the Woodman Hall in 1911. At left is a Mr. Webber, the teacher. The boys in the car's front seat are (from left to right) Frank Allen, Ira Bourm, and Jim Landers. In the back seat are Tru (Gertrude) Allen, Bertha Cantlin, Lee Wright, and Jane Jones. (Courtesy of the Paul Allen Collection.)

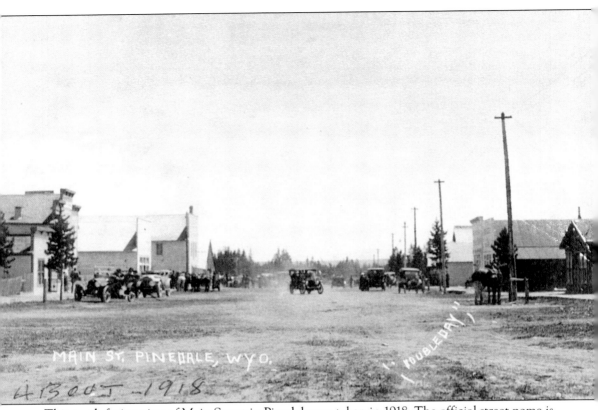

This south facing view of Main Street in Pinedale was taken in 1918. The official street name is Franklin Avenue, named by town founder John F. Patterson's oldest son. Note the early electric lines on the right-hand side. Electricity was available in Pinedale as early as September 1904. Only a few hundred people lived here at this time, yet there are several cars. (Courtesy of Sublette County Historical Society.)

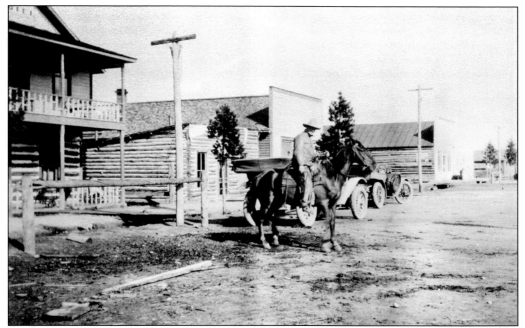

An unidentified rider pauses in front of the Pinedale Inn on Franklin Street in the 1920s. Western writer Zane Grey stayed here on his visits to Pinedale. Also pictured to the right of the inn are the telephone company; the State Bank of Pinedale; and the Jones, Son, and Company General Mercantile. Note the automobiles in the street with the horseback rider. (Courtesy of Sublette County Historical Society.)

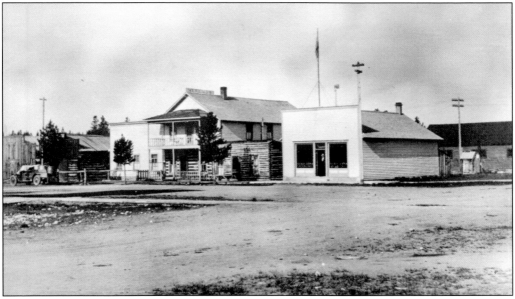

In 1916, the Bourm Hotel, operated by Henry Clodius, was commonly known as the Pinedale Inn. The hotel is the two-story building next to the telephone company and the State Bank of Pinedale on south Franklin Street. Note the early electric lines and trademark pine trees along Pine Creek. (Courtesy of Sublette County Historical Society.)

Madelyn and Frances Wilson play in front of their home in Pinedale in the 1920s. Despite the isolation of the community, note the fashionable clothes and hairstyles the girls are wearing. (Courtesy of David Takacs.)

Wilson Hall was built in 1923 by John and Dave Wilson on the south side of Pine Street between Fremont and Sublette Avenues. This was an important community gathering place for movies, plays, dances, fund-raisers, and similar events for decades. The Wilson home is directly behind the hall. (Courtesy of David Takacs.)

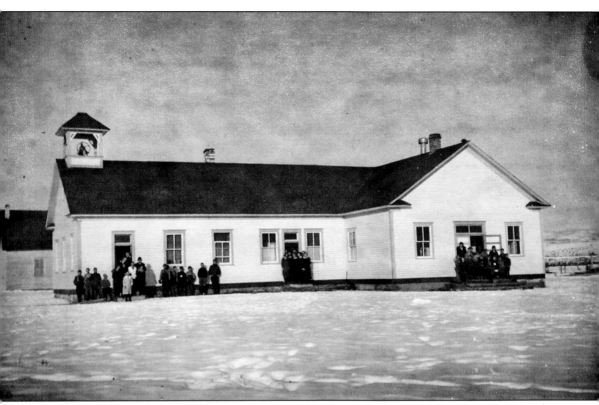

Children from grades one to eight were educated in this schoolhouse from 1912 to 1923. Only town and nearby ranch children were able to attend in winter because the heavy snows made travel difficult. The white clapboard building was the town's second schoolhouse. The original school was built in 1904 but was too small for the growing town by 1912. (Courtesy of Sublette County Historical Society.)

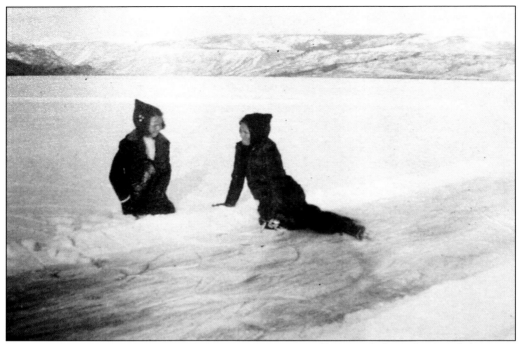

Fremont Lake is frozen solid usually from December until May every year. One popular activity throughout the years has been ice-skating, though clearing snow from the ice is usually required. Pictured above are two local girls taking a break from their ice-skating excursion on the lake in the 1920s. (Courtesy David Takacs.)

Dave Wilson is seen at left cutting ice out of Half Moon Lake. Ice blocks cut from lakes or creeks during the winter were stored in "icehouses," usually insulated with sawdust, to be used in the summer. The blocks of ice were the only form of refrigeration for the early settlers. (Courtesy of David Takacs.)

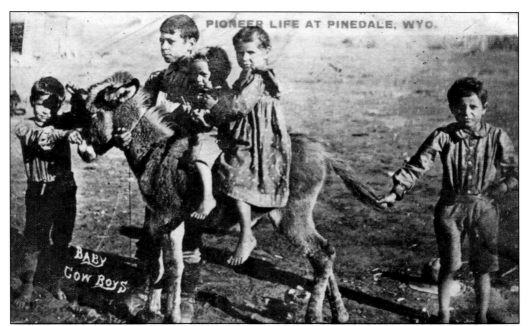

The photograph on this postcard, featuring children on and around a small burro, was likely a typical sight. The community was home to many young families, and everyone used animals for work, transportation, and, occasionally, pets. (Courtesy of Sublette County Historical Society.)

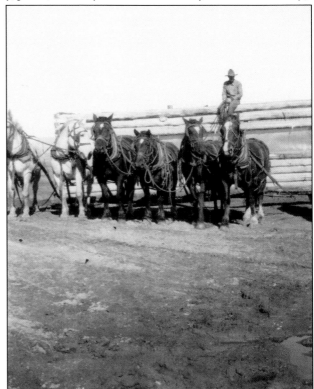

This line up of workhorses is pulling a building to another location. It was common for the early, simple, log buildings to be moved. Schoolhouses may have been the most frequently moved structures, especially on ranches, where they were moved to be closest to the most children. (Courtesy of Mike and Ruth Noble.)

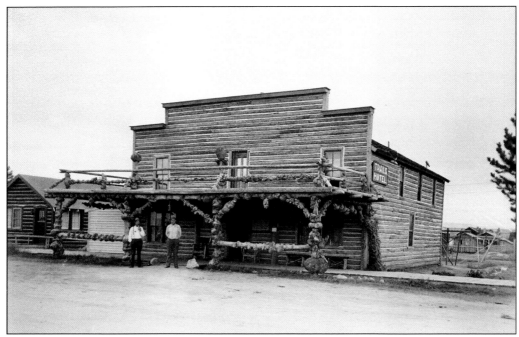

This was the first hotel in Pinedale, built in 1904 by E. N. Sprague and located on the town's main street, at that time Franklin Avenue. Later owners John W. and Minnie Bloom referred to it as the Bloom Hotel until they renamed their establishment the Old Trails Hotel in the 1920s, as it appears here. (Courtesy of Sublette County Historical Society.)

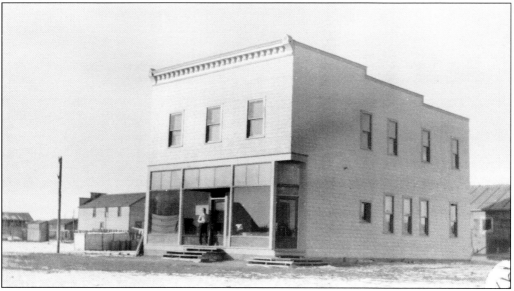

The Fardy Hotel, formally dubbed the Pines Hotel, was owned and operated by Gus and Ida Caviter Fardy until Gus's untimely death in 1931, at which time Ida Fardy took over the hotel, restaurant, and bar. Her frugal business practices kept her in business during the Great Depression of the 1930s. She was long remembered for her generosity toward those in the community most in need. (Courtesy of Sublette County Historical Society.)

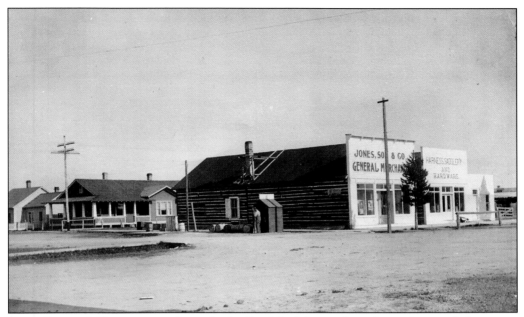

Jones, Son, and Company was formerly the Franklin Mercantile and was the town's first store. The *Pinedale Roundup* of June 22, 1911, reported: "The dance given by Jones, Son & Co. last Saturday evening in the new store building was well attended and a fine time had by all, many were unable to attend on account of high water, weather conditions and the short notice." (Courtesy of Dorothy Noble.)

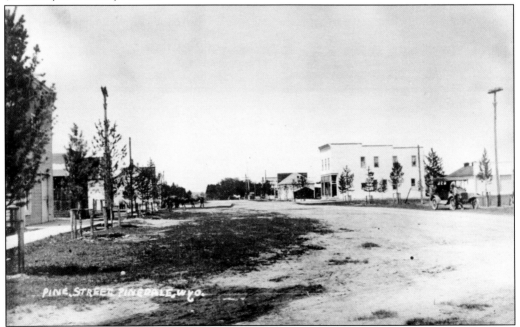

This 1920s scene of Pine Street features the Pines Hotel on the right. Note the automobile on the right-hand side of the street, while the left side still has hitching posts for horses. Pine trees planted by the townspeople along the street were thriving. (Courtesy of Dorothy Noble.)

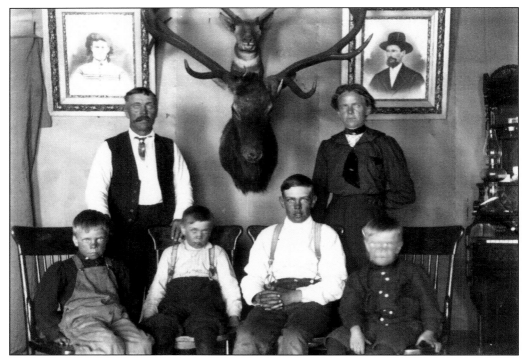

Arthur Faler and his wife, Christine Petersen, stand behind their four children in this family portrait, taken in 1915. The Falers were among the earliest settlers in the area. The elk head on the wall was killed by Arthur and was later given as collateral to Billie Postel for hay. Apparently, Faler never went back for the mount with money to pay for the hay. (Courtesy of Sublette County Historical Society.)

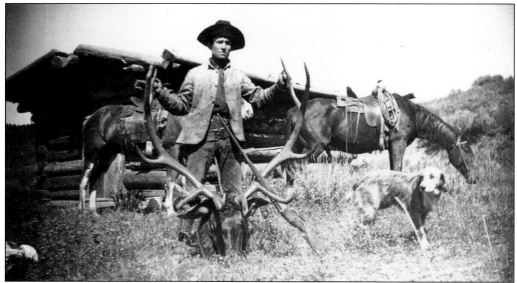

The hunter, identified only as Boulsby, shows off his elk trophy and gun. The trophy heads were coveted but so too was the meat from the animal. A large kill could sustain a family during the winter. (Courtesy of Sublette County Historical Society.)

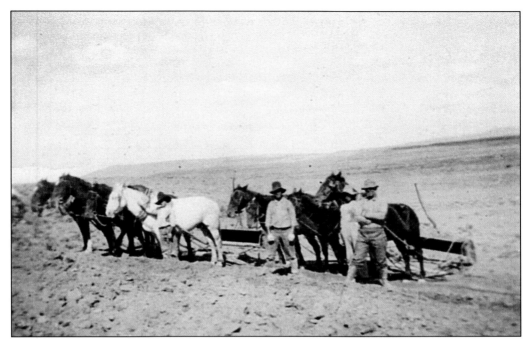

Road building and improvements were ongoing for the early Pinedale settlers. Pictured here is an early Fresno scraper work in 1920. Horse-pulled Fresnos were used to scrape and move dirt. (Courtesy of Ralph and Charlotte Faler.)

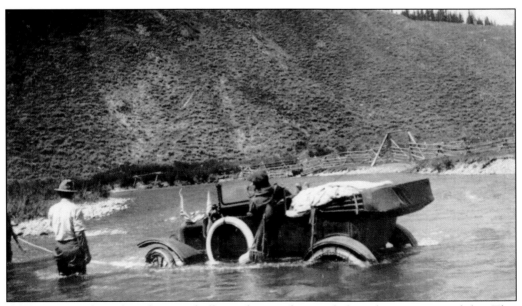

River crossings have long been a challenge for travelers, including those in automobiles. This traveler is being assisted with a pull across the Hoback River north of Pinedale at the V-V Ranch. The dudes of Pinedale resident Thomas Lars Clementsen are on their way to Yellowstone National Park in 1915. (Courtesy of Pat and Ben Pearson.)

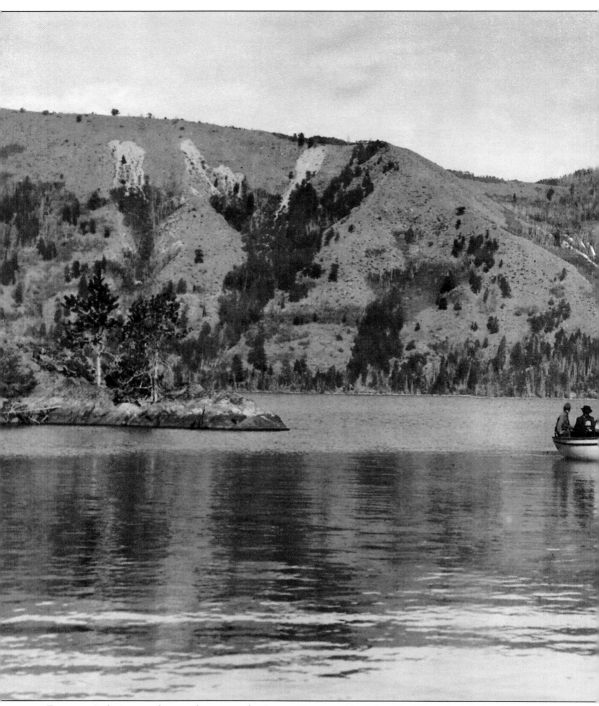

Fremont Lake's most famous boat was the *Laura E.*, owned by John H. ("Beer Jack") Anderson, the mayor of Rock Springs and a saloon owner. It is seen here floating into the peaceful Box Bay on Fremont Lake. The *Laura E.* was hauled from Rock Springs by a wagon and six horses in May 1914 and was launched with ceremony. Built by the Brooks Boat Company of Michigan, it was 30 feet

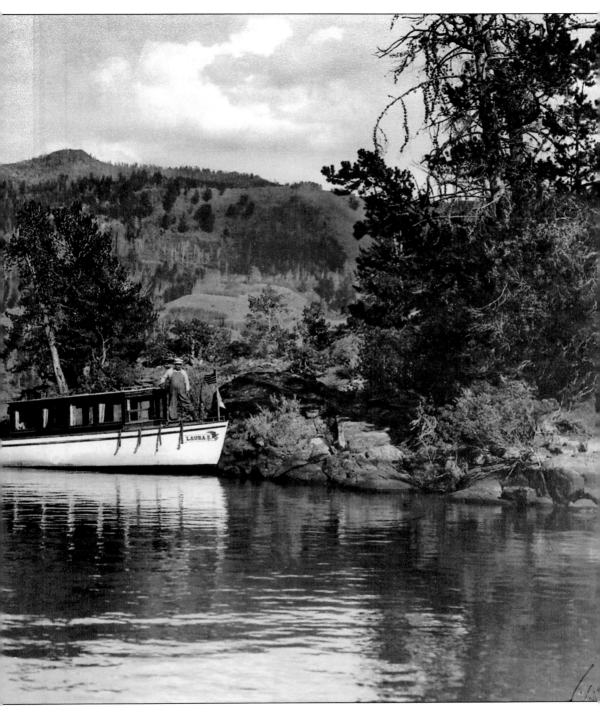

long, had a 9-foot beam, and was mostly enclosed, with an elegant wood-and-glass cabin. It was powered by a 2-cylinder, 14-horsepower engine. The mayor planned to move the city government to the boat during the hot summer months, which is not believed to have happened. Wyoming photographer Joseph E. Stimpson took this photograph. (Courtesy of Ann Chambers Noble.)

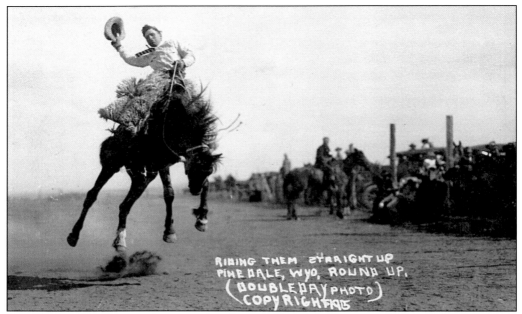

Ralph R. Doubleday was a famous rodeo photographer, capturing action shots of the sport from 1910 to 1965. He would get in the arena with the rodeo contestants to obtain his pictures. He captured this photograph at a rodeo in Pinedale in 1915. "Riding them straight up," is what he called this picture. The rider looks sharp with his angora chaps, white shirt, and tie! (Courtesy of Ralph and Charlotte Faler.)

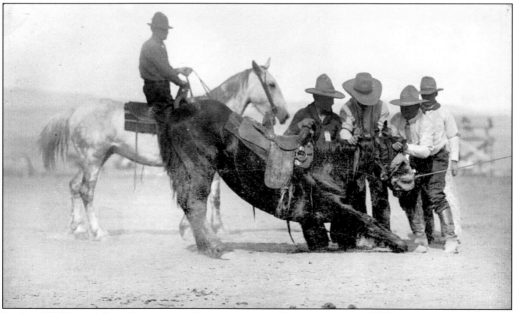

In this 1915 Pinedale rodeo picture, the cowboys are "earing 'im down." This was a rodeo practice of twisting a horse's ear, or even biting it, to subdue it while blindfolded. This usually brought the horse to a kneeling position, enabling a cowboy to mount before his ride. (Courtesy of Ralph and Charlotte Faler.)

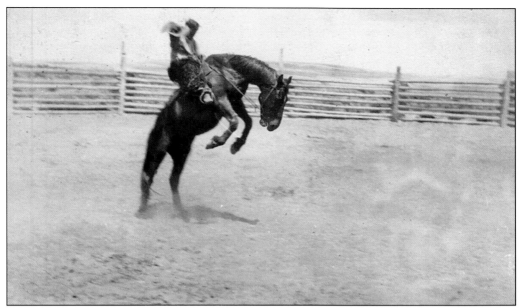

Less Faler is photographed here riding a bucking horse in 1919. "Breaking horses" required the rider to stay on until the horse quit bucking. Eventually, the horse would, hopefully, be able to work with a cowboy rather than just give him a ride. (Courtesy of Ralph and Charlotte Faler.)

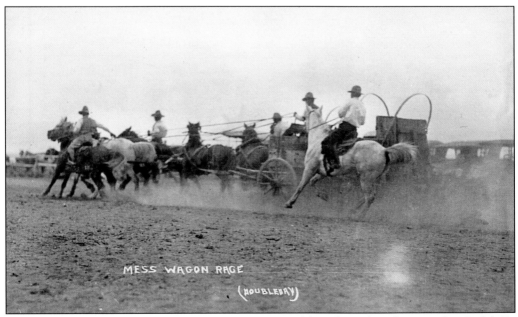

A popular entry was the Mess Wagon Race, captured here by rodeo photographer Ralph R. Doubleday at a 1915 Pinedale rodeo. These competitors were required to bring in their wagons, light fires, prepare and eat dinner, set up bedrolls, go to "sleep," and then pack up and leave as fast as possible to beat their competitor. (Courtesy of Ralph and Charlotte Faler.)

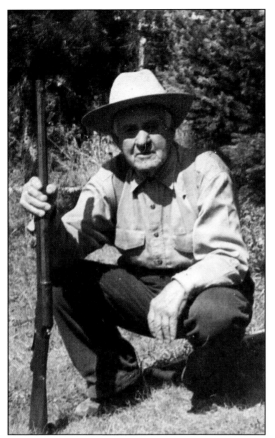

Vint Faler poses with one of his life's prized possessions, Jim Baker's rifle. Baker, a 19th-century frontiersman, mountain man, and government scout, gave the gun to Faler in 1885 when Faler was only a boy. Faler moved to the Pinedale area in 1889 with his family. The Falers were among the earliest white settlers in the area. (Courtesy of Ralph and Charlotte Faler.)

Vint Faler's freight team was a familiar sight along the Wind River Mountains throughout the early 20th century. Faler's jerk-line team delivered loads from Rock Springs and Green River to South Pass and Pinedale. Faler and his horses retired from freighting when gasoline-operated vehicles replaced them. (Courtesy of Ralph and Charlotte Faler.)

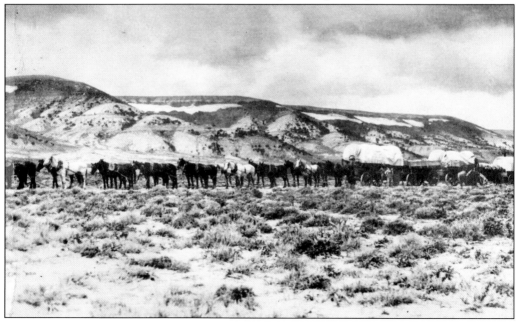

Two

SUSTAINING A FRONTIER TOWN

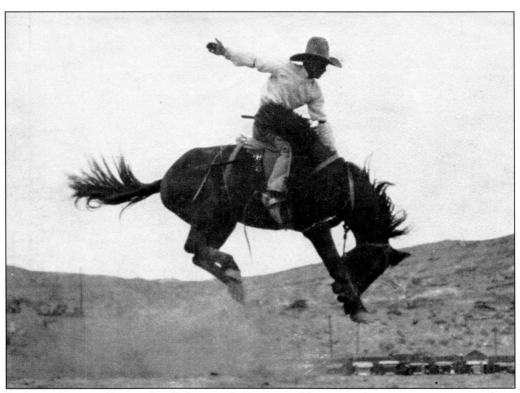

Early ranchers used horses for all their work. Taming wild or young horses was an ongoing chore for the cowboy. This work was referred to as "breaking" a horse to ride or work. It took great skill, and this talent became the basis of the rodeo. Shown here is an area cowboy in the 1920s on a "buckin' horse" at a local rodeo. (Courtesy of Sublette County Historical Society.)

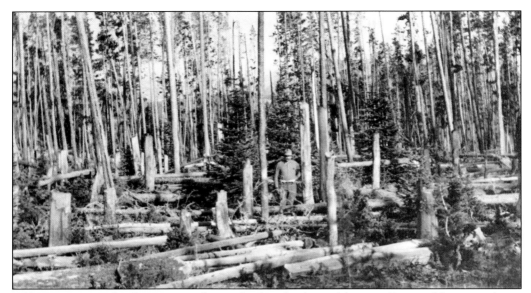

Felling trees was the first step in the work of tie hacks and loggers. Pictured here is a forest harvested for logs. It was common to harvest logs in the winter then gather the logs in springtime. Note the high tree stumps in this photograph, indicating a winter cutting. (Courtesy of Sublette County Historical Society.)

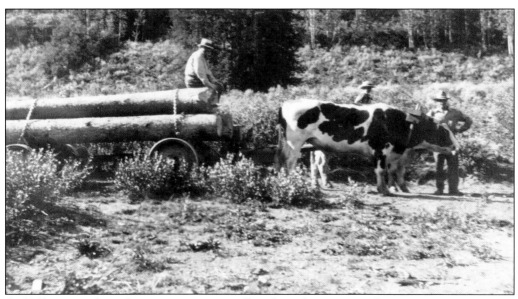

Cy Kelly is seen here driving an ox team pulling large logs to town for a construction project. Sawmills were set up in Pinedale and the surrounding areas during the early settlement years, enabling the town to provide lumber for its own building projects. (Courtesy of Sublette County Historical Society.)

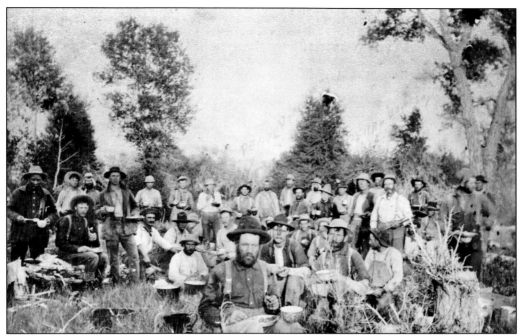

Men came from around the world to cut the pine trees in the Wyoming mountains. The trees they cut were hewn before floating down rivers to be used to lay the tracks for the transcontinental railroad. These workers became known as tie hacks. Pictured here is lunchtime for the tie hacks around 1904 in Kendall, north of Pinedale. (Courtesy of Sublette County Historical Society.)

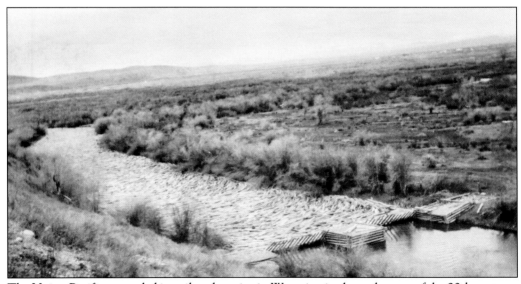

The Union Pacific expanded its railroad service in Wyoming in the early years of the 20th century, creating a demand for ties to support the new rails. In springtime, the rivers around Pinedale were full of freshly hewn logs, making their way to new rail lines across southern Wyoming. Pictured here are rail ties headed down river to the town of Green River. (Courtesy of Sublette County Historical Society.)

Irv Lozier, owner of the Box R Ranch, is shown at left in 1904. Lozier's dude ranch is located in Cora, north of Pinedale. Lozier and his outfit took guests into the Wind River Mountains on horse-pack trips for fishing and hunting expeditions. (Courtesy of Irv Lozier.)

Guests coming to the Box R Ranch often traveled from far away to enjoy a hunting expedition in western Wyoming. Pictured below is a four-horse wagon bringing dudes on the last leg of their trip to the Box R Ranch from Opal, the railhead west of Kemmerer, in September 1903. (Courtesy of Irv Lozier.)

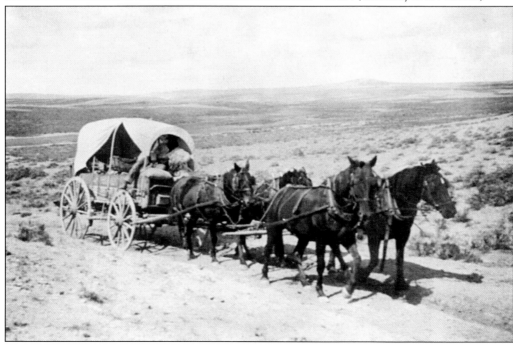

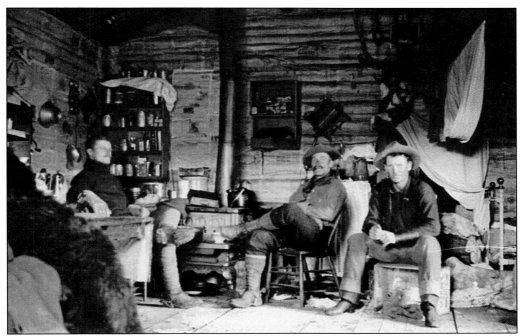

From left to right, Box R guests Hubert Litchfield Jr., H. Sampson Jr., and C. A. Comstock relax at the ranch in October 1904. The gentlemen came to the area for an elk-hunting trip, which was successful. Guests often stayed several weeks. (Courtesy of Irv Lozier.)

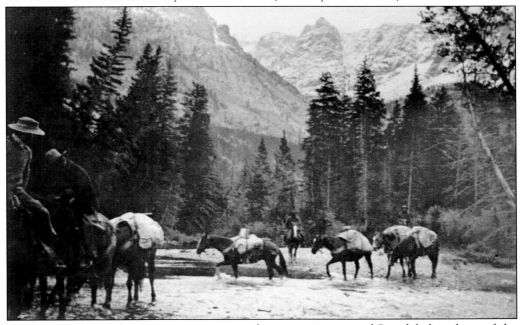

Western painter Carl Rungius spent time in the mountains around Pinedale based out of the Box R Ranch. Rungius often painted from photographs he took while on trips with the Loziers. Rungius later made this September 1904 pack-trip photograph, taken in Green River Canyon, into a painting. (Courtesy of Irv Lozier.)

Snows come early in western Wyoming. Irv Lozier rides his horse through belly-deep snow near his Box R Ranch, leading hunting guests. (Courtesy of Irv Lozier.)

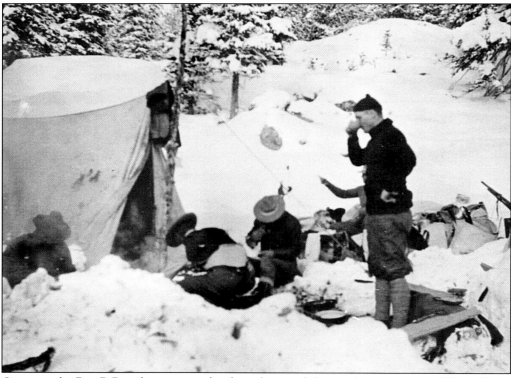

Guests at the Box R Ranch camp in a few feet of snow while on a hunting trip in 1904 at Heart Lake in the Wind River Mountains. Snowstorms were common on hunting expeditions in western Wyoming. (Courtesy of Irv Lozier.)

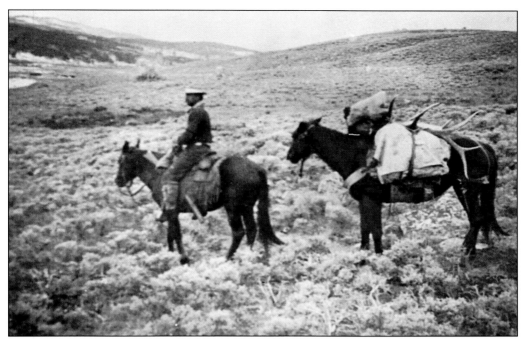

Irv Lozier packs out an elk head and rack for one of his guests, Henry Sampson Jr., in October 1904. Hunters came from around the world for big-game hunting trips at the Box R Ranch, near Pinedale. (Courtesy of Irv Lozier.)

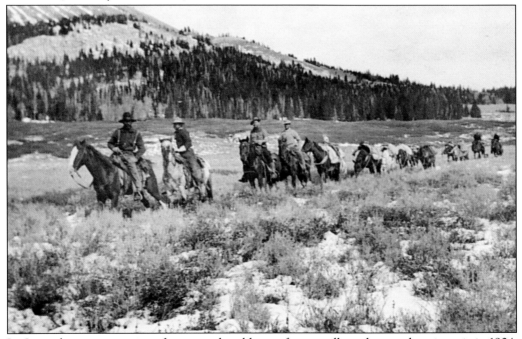

Irv Lozier brings out a string of guests and packhorses from an elk- and moose-hunting trip in 1904. Hunters were usually successful in getting their trophy animals in the Wind River Mountains at this time. (Courtesy of Irv Lozier.)

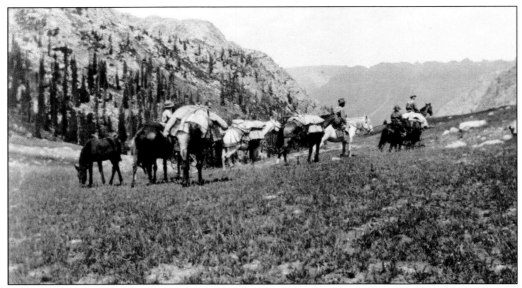

Horse-pack trips into the mountains surrounding Pinedale, particularly in the Wind River Range, have long been a popular activity for locals and tourists alike. Pictured here is a horse-pack string in the high country around 1930. (Courtesy of Sublette County Historical Society.)

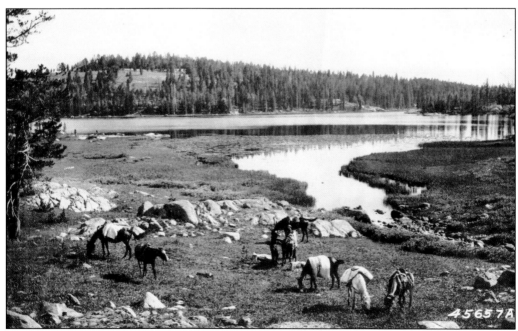

Horses were able to get riders and their gear high into the Wind River Mountains. Pictured here are packhorses resting at a high mountain lake in 1930. (Courtesy of Sublette County Historical Society.)

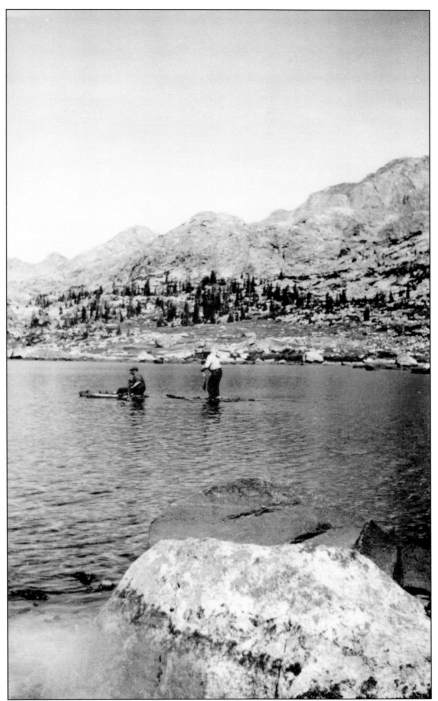

Walt McPherson (left) and Carroll Richard Noble are seen here enjoying the Wind River Mountain high country. They built the raft for their fishing expedition, with plans to "catch the big one!" Many visits to the mountains were also successful fishing trips. (Courtesy of Mike and Ruth Noble.)

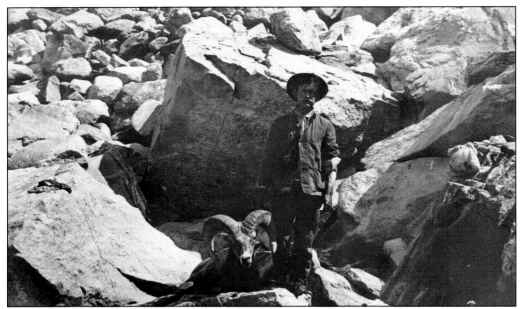

A Mr. Basham from Missouri is pictured here with his mountain sheep trophy in the early 1910s. The Wind River Mountains are home to several big game animals, such as the mountain sheep, and has long been a popular hunting area. (Courtesy of Mary Ellen Steele.)

Pinedale rancher Frank Steele (right) is leading his hunting friend from Missouri, a Mr. Basham, back to the Steele ranch after a successful mountain sheep–hunting trip in the Wind River Mountains in the early 1910s. Both men's packhorses are carrying their hunting trophies. (Courtesy of Mary Ellen Steele.)

Horses were used to navigate the difficult mountain terrain of the Wind River Mountains. Photographed here is Pinedale rancher Frank Steele with his friend, a Mr. Basham. Their packhorses are carrying their successful mountain sheep trophies. (Courtesy of Mary Ellen Steele.)

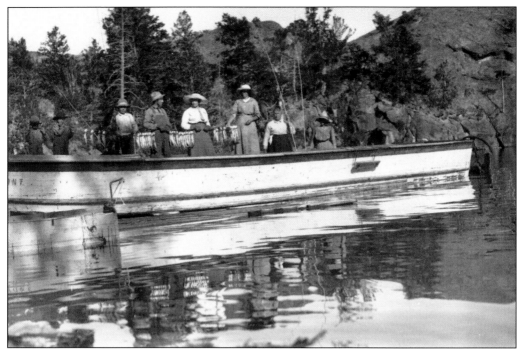

Fremont Lake, located three miles north of Pinedale, has long been a popular place for locals and tourists to relax and visit. Pictured here is a fishing party in 1915, with the ladies showing off their day's fishing catch. (Courtesy of Sublette County Historical Society.)

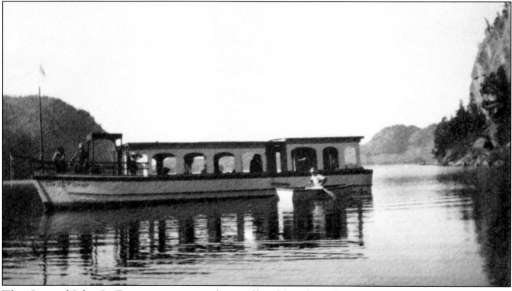

The *General John C. Fremont* excursion boat offered locals and tourists cruises around Fremont Lake starting in 1911. In October 1912, the big boat sank while it was tied up near Box Bay when a small boat tied to its side wore a hole in it. It was pulled to shore and repaired but later sank again, this time in deeper water southeast of Box Bay, where it remains. (Courtesy of Sublette County Historical Society.)

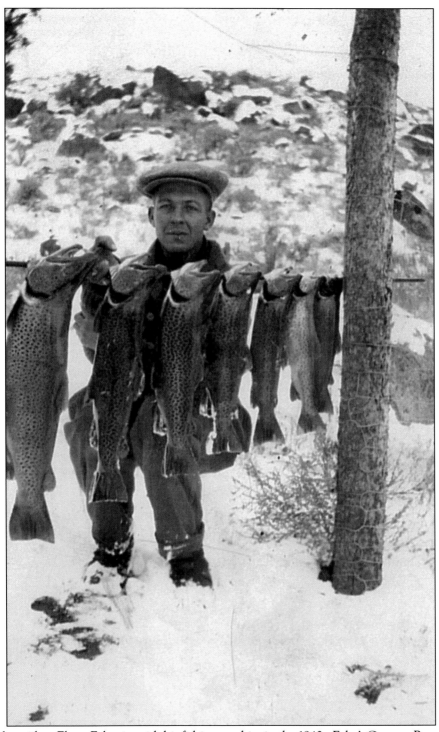

Pinedale resident Elmer Faler sits with his fishing trophies in the 1940s. Faler's German Brown trout were caught near the power plant on Pine Creek. (Courtesy of Ralph and Charlotte Faler.)

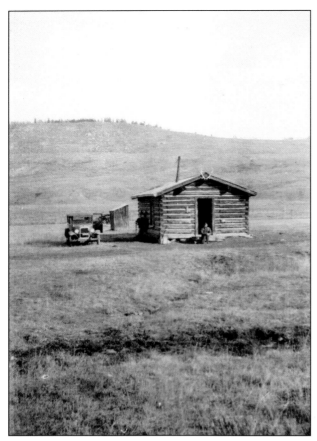

It was not unusual for women to homestead in Wyoming. This is Freida Noble Hittle's homestead cabin in Bondurant, north of Pinedale. Note the outhouse in back. It was common to see automobiles at various ranch homes in the early 20th century, but most of the ranch work was done with horses. (Courtesy of Mike and Ruth Noble.)

The James and Minerva J. Westfall family proudly poses in front of their cabin on their homestead north of Pinedale in the 1890s. Note the baby antelope in front and next to the young man. This structure has already had an addition put on the back and has glass-paned windows. (Courtesy of Mike and Ruth Noble.)

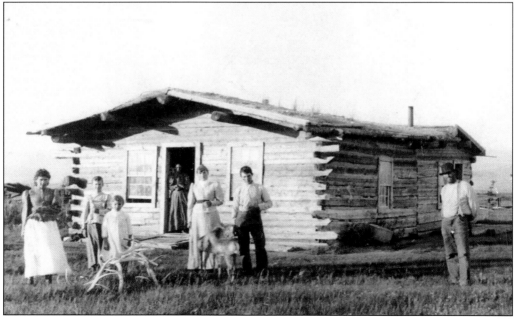

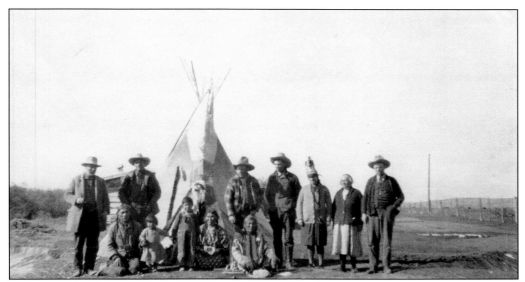

Pictured here in the late 1920s at the James Noble Ranch north of Pinedale is Shoshone chief Neep-a-Water (kneeling, front), surrounded by his family from the Wind River Reservation. James Noble stands on the far right next to his wife, Pauline. Also pictured are seven unidentified, Nels Jorgensen, Ted Wineman, and his wife from Pennsylvania. (Courtesy of Mike and Ruth Noble.)

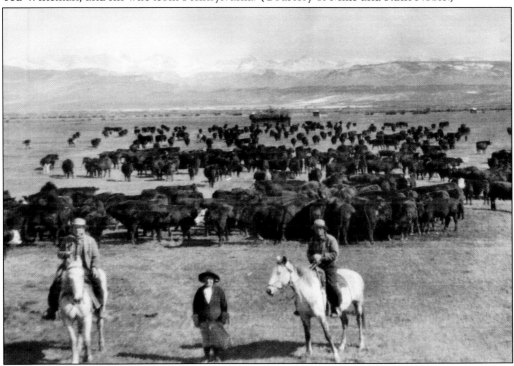

James Noble (left), Pauline Rahm Noble (center), and Shoshone chief Neep-a-Water (right) were photographed in 1928 in front of the Noble cattle herd in Cora. The cattle are Black Angus and will become part of the oldest continuous Black Angus herd in Wyoming. The span of the Wind River Mountains is visible from the ranch. (Courtesy of Mike and Ruth Noble.)

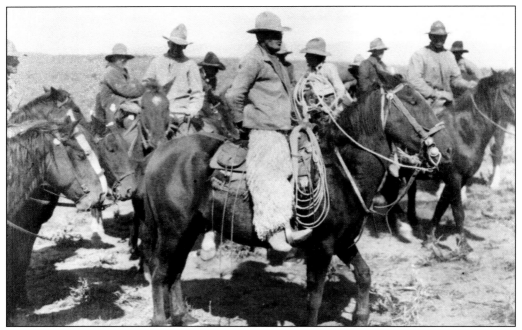

Cattle from local ranches grazed in the high mountains north of Pinedale in the summer and on the open mesa south of town in the spring. Gathering the cattle took numerous cowboys, such as the group pictured here, to cover the miles of ranch terrain. (Courtesy of Sublette County Historical Society.)

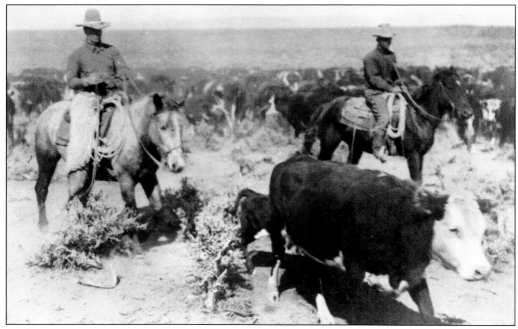

Carl Jorgensen, wearing angora chaps on the left, was one of the early Pinedale cattle ranchers. He is seen here on horseback pushing a cow and her calf, likely to summer range. (Courtesy of Sublette County Historical Society.)

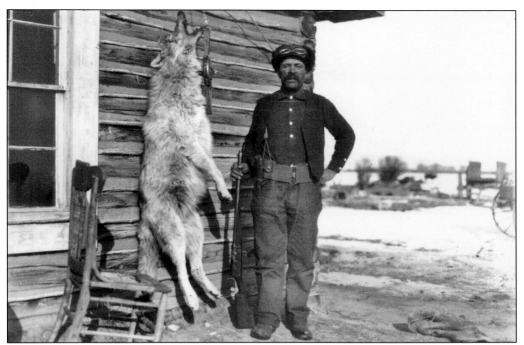

Arthur Faler stands with his wolf kill in early 1900. Wolves were killed in the area to enable cattle and sheep ranching to survive. At various times, the United States and Wyoming state government paid hunters to kill the predators. Ranchers also formed bounty associations and paid dues to fund predator control. (Courtesy of Sublette County Historical Society.)

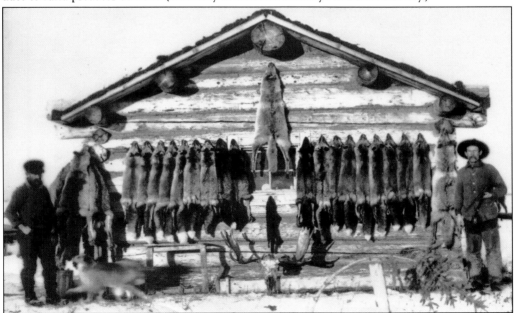

Pinedale-area trappers display their harvest in early 1900. Trappers were paid by the pelt, bringing a welcomed income where paychecks were hard to get. (Courtesy of Sublette County Historical Society.)

Frank Steele is pictured here around 1912. Steele came to the area in the late 1880s as a baby when his parents, Ed and Emma P. Steele, homesteaded in the Boulder area, east of Pinedale. Frank later moved to the west side of Pinedale, where several of his family members homesteaded on the New Fork River. (Courtesy of Erma Shriver.)

"Look at the camera," the boy in the saddle seems to be saying to his younger brother sitting behind him. The boys, James Richard and Carroll Richard Noble, lived on a Pinedale-area ranch. They are pictured here returning from a hunting expedition in early 1900. Hanging on their saddle with their shotgun appears to be a badger and two sage grouse. (Courtesy of Pat and Ben Pearson.)

Many children were born and raised in Pinedale and on area ranches. Pictured here in the early 1930s are, from left to right, Mike Noble, Bill Thompson, and the Feltner children—Wayne, Juana, and Elma. The baby is not identified. (Supporting the baby is a mother behind the horse). The patient horse, Old Pig, seems content with her load. (Courtesy of Pat and Ben Pearson.)

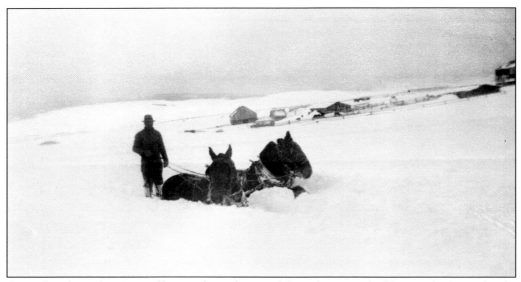

A rancher drives his team of horses through several feet of snow to feed his cattle. Snow depths between six and eight feet were common in the early 20th century. The snow often came early and stayed late, covering the ground from October until May. (Courtesy of Sublette County Historical Society.)

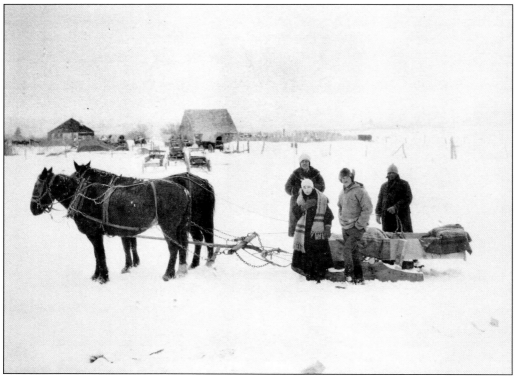

Members of the Wilson family are bundled against the cold temperatures. Winter travel by horse and sleigh could be quite frigid. (Courtesy of Dave Takacs.)

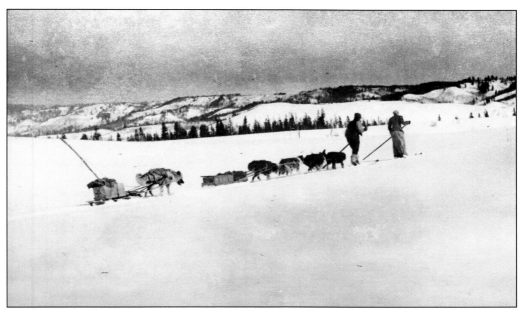

Common forms of winter transportation in the early 20th century were dogsleds and skis. Seen here are ranchers returning on skis with supplies or mail pulled on sleds by their dogs. (Courtesy of Sublette County Historical Society.)

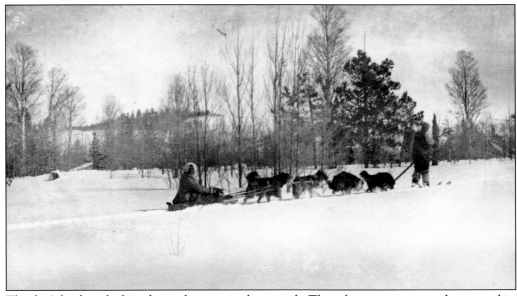

The dog's load is a lucky rider in this winter photograph. The other person pictured is using skis, which were usually homemade. Leather straps connected the skier's boots to long, wide boards. (Courtesy of Sublette County Historical Society.)

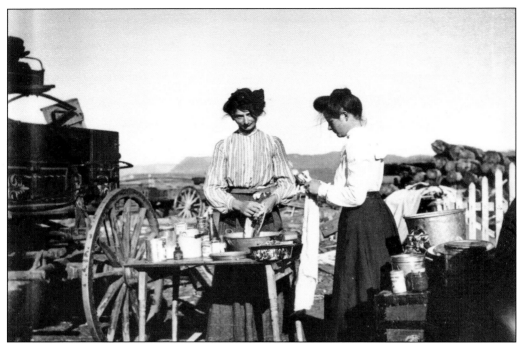

Grace Alexander and Clara Alexander are attending to the dishes at their home on the upper New Fork River in 1907. The Alexanders were one of the earliest families to homestead in the Upper Green River Valley. (Courtesy of Sublette County Historical Society.)

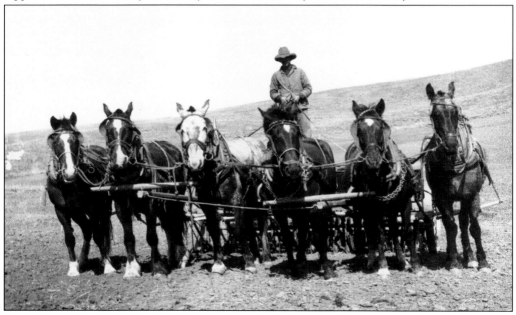

An early rancher and his team of horses plow this field to establish a hay meadow. At Pinedale's high altitude, starting at 7,175 feet, area ranchers are able to harvest only one hay crop annually. With the long winter, getting the most of the crop was critical. (Courtesy of Sublette County Historical Society.)

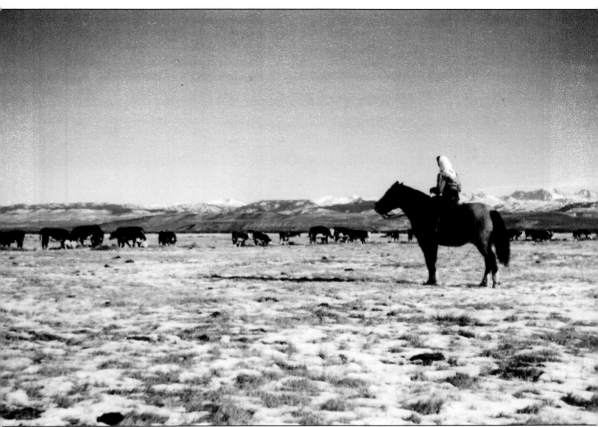

Mary Ellen Steele watches over the Steele family cattle in November 1947 on their New Fork River homestead, located west of Pinedale in view of the Wind River Mountain range. Like many ranchers in the area, the Steeles raised Hereford cattle. (Courtesy of Mary Ellen Steele.)

Pinedale townspeople often helped area ranchers with their brandings. Pictured here are several cowboys and helpers at the Noble Angus Ranch in Cora, west of Pinedale. The pay for the hard day's work was a big dinner prepared by the ranch wife. (Courtesy of Mike and Ruth Noble.)

Mike Noble (center) is getting ready to grab the roped calf for branding. Area ranchers took turns helping one another at brandings, which required many extra workers. The brands put on the cattle were often handed down through the family for generations and were a source of pride for the ranchers. (Courtesy of Mike and Ruth Noble.)

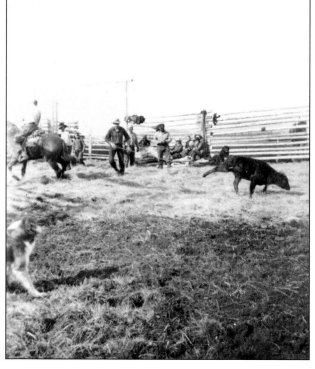

Carroll Noble, on horseback, and his son Mike are trying to sort their Black Angus cattle in the corral. The animals were often unruly after a summer on the open range. It took an astute cowboy to work with the cattle. (Courtesy of Mike and Ruth Noble.)

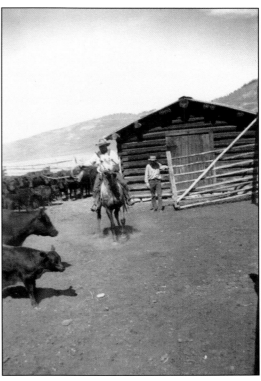

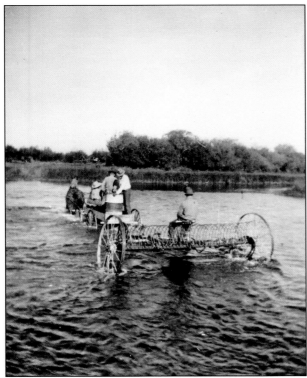

A single horse is pulling a wagon and dump rake with hay crewmembers across the Green River. Rivers could be challenging to cross with all the haying equipment, even in the low-flow, late-summer waters. Note the rubber tire dangling inside the large metal wheel. This helped prevent hay from tangling between the rake teeth and wheel. (Courtesy of Mary Ellen Steele.)

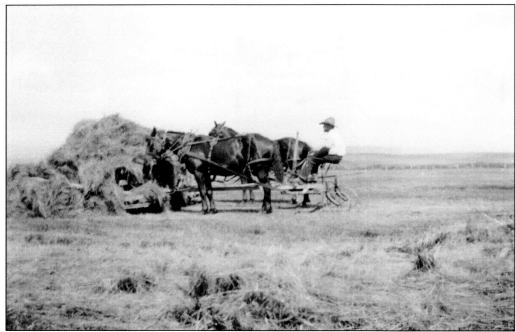

A Pinedale-area rancher is bringing in the hay crop in this photograph. The two horses are pushing a sweep, which gathers windrows of hay into big piles. The piles were then pushed up the beaver slide, a large log slide, into the stack. Ranchers often made their own haying equipment. (Courtesy of Erma Shriver.)

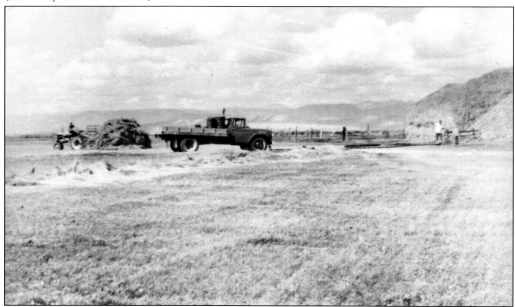

Ranchers are making hay on the Steele Ranch in August 1958. The driver to the left is sitting on a tractor modified to work as a sweep, which brings piles of hay to the base of the slide. In the middle is the plunger truck, which is responsible for pushing the hay up the beaver slide, visible on the far right edge of the photograph. (Courtesy of Mary Ellen Steele.)

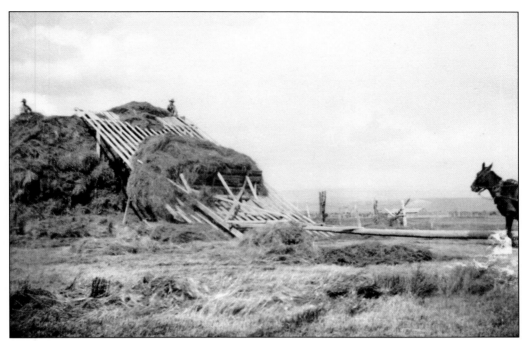

Working on the stack, these two men, appropriately called "stackers," are waiting for their next load of hay, which is being pushed up the beaver slide by horses pushing the plunger. The stackers' job required careful placement of the hay on the stack to assure it would stay. Stackers often took great pride in how their stacks looked when completed. (Courtesy of Erma Shriver.)

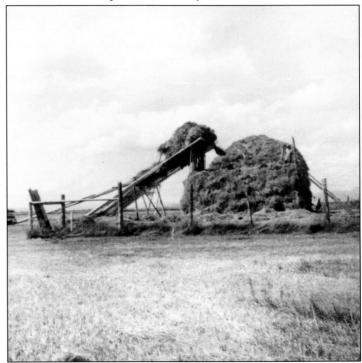

In this Pinedale-haying photograph, again on the Steele Ranch in 1958, a load of hay is pushed up the beaver slide onto the stack with a truck. Note the man working as the stacker near the top of the haystack. (Courtesy of Mary Ellen Steele.)

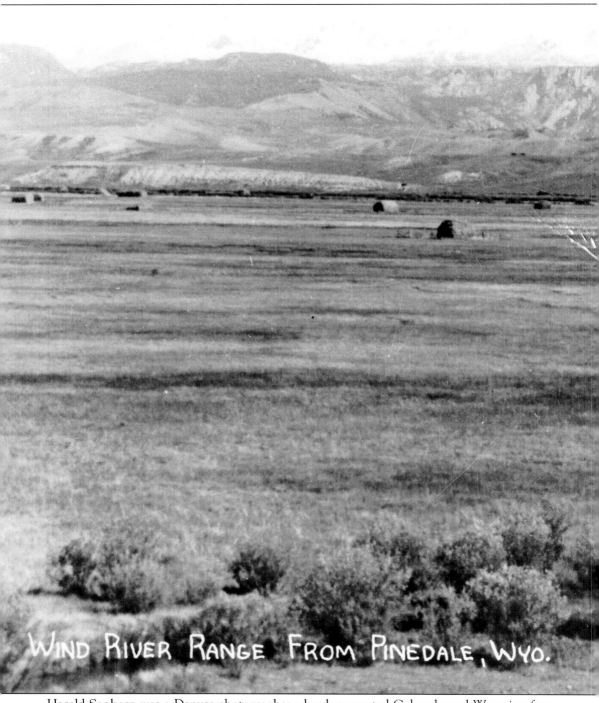

WIND RIVER RANGE FROM PINEDALE, WYO.

Harold Sanborn was a Denver photographer who documented Colorado and Wyoming from the 1920s until the 1960s. Many of his photographs were made into postcards. This Sanborn photograph of the "Wind River Range From Pinedale, Wyoming" was taken in the 1930s and has his trademark name and photograph number in the bottom right corner. This particular postcard

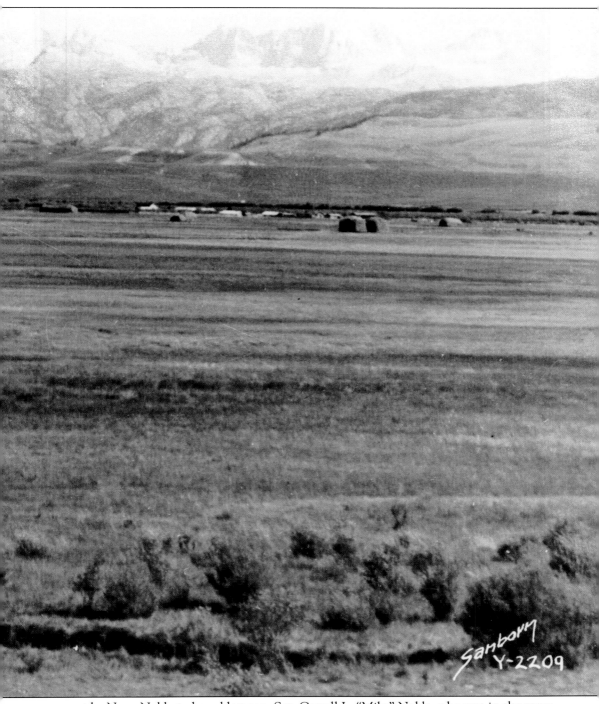

was sent by Nean Noble to her oldest son, Sgt. Carroll L. "Mike" Noble, who was in the army during World War II in the Philippines. "Dear Mikey," the message reads, "I thot this was a good mountain scene. Love from all, Nean." (Courtesy of Mike and Ruth Noble.)

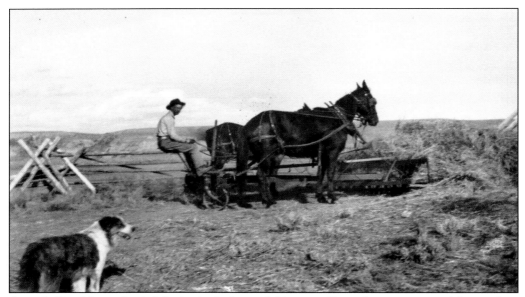

An early Pinedale rancher is bringing in the hay with his sweep. Dogs often accompanied the ranchers in all their work, as shown in this picture. (Courtesy of Sublette County Historical Society.)

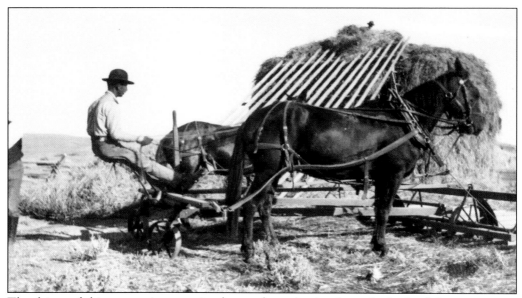

The driver of this sweep sits on a simple metal seat jutting from the back of the equipment. Ranchers claimed these were very comfortable. Well-trained horses maneuvered equipment around the field efficiently. (Courtesy of Sublette County Historical Society.)

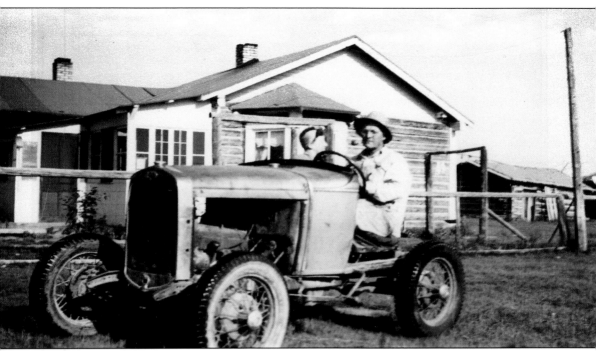

Frank Steele and family friend Leonna Mae Allen visit in front of his ranch house in the 1950s. Note Steele's modified tractor. It was common for ranchers to cut down an old car and move the axles closer together. These modified vehicles were able to turn quicker, making them more useful for ranch work. (Courtesy of Erma Shriver.)

Ranch children started working in the hay fields at young ages. Donald Shriver sits in the driver seat while Fred Shriver sits on the left next to Frank Shriver during a 1950s haying season. The Shriver family purchased a ranch west of Pinedale in 1944 and always used vehicles in their operation; their neighbors were often still using horses. (Courtesy of Erma Shriver.)

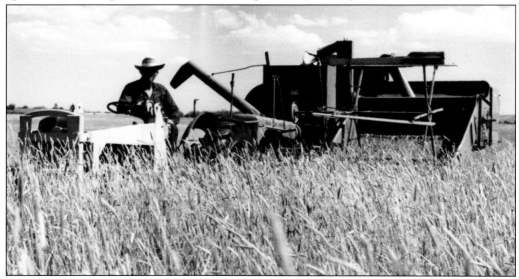

Fred Shriver is pictured here harvesting meadow foxtail seeds on August 3, 1960, in fields west of Pinedale. Shriver purchased a combine for the harvesting when the prices were good for the new seed. He usually yielded 200 pounds of seed per acre. (Courtesy of Erma Shriver.)

Three

BUILDING A TOWN

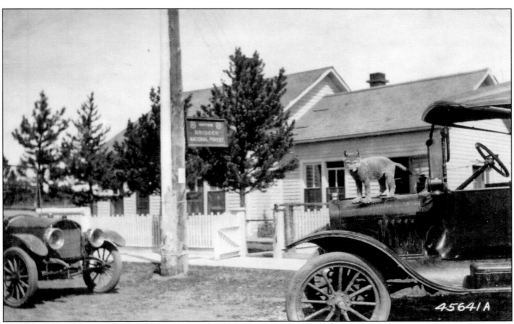

A wolf pup is standing on the hood of a Ford Model T parked in front of an early U.S. Forest Service office in Pinedale. The U.S. Forest Service has had a presence in Pinedale since the spring of 1905 when Supervisor Zeph Jones moved the office onto two lots donated by the town. Jones would serve as Pinedale's first mayor from 1912 to 1913. (Courtesy of Sublette County Historical Society.)

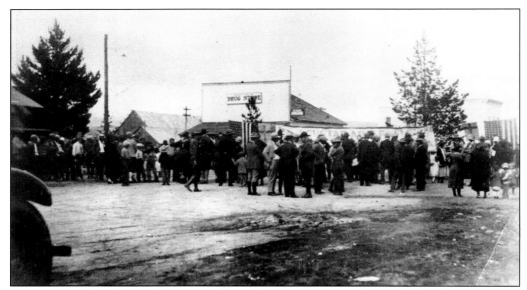

A major event for the usually quiet and isolated town occurred on July 8, 1926, when the crown prince of Sweden visited Pinedale. Townspeople and folks from the surrounding communities came to greet the royalty. Pictured here is the welcoming crowd for the prince gathered along Franklin Avenue at the intersection of Pine Street. (Courtesy of Paul Allen.)

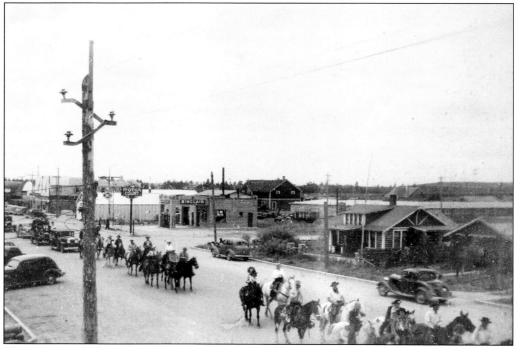

This early parade down Pine Street features a posse of horses and riders in front of a few automobiles during the 1930s. Parades were a common part of the town's Fourth of July celebrations. (Courtesy of David Takacs.)

Prior to World War II, most of the people living in and around Pinedale did not own cars. Transportation services, therefore, were important. Pictured here is Walter Scott, owner of the Scott Stage Company, in his vehicle. Scott made regular trips to and from Rock Springs. (Courtesy of Jack Doyle.)

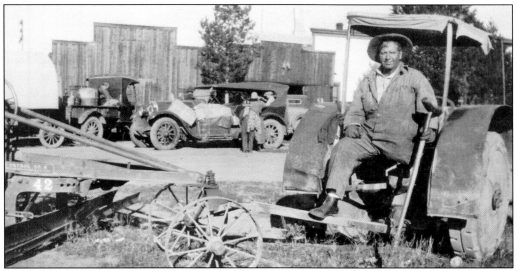

Art Doyle sits on his tractor, attached to the road grader on the left, that he used to maintain the road from Pinedale to Rock Springs throughout the 1920s. Note the tractor's metal wheels. Doyle lost his leg at 16 years of age while working cattle in Mexico. In his later years, he would tell people that he climbed into a haystack, fell asleep, and a pig came and ate his leg off. (Courtesy of Jack Doyle.)

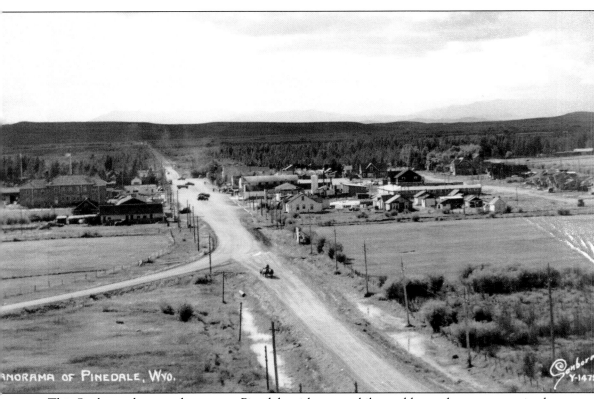

This Sanborn photograph captures Pinedale with automobiles and horse-drawn wagons in the late 1930s. The photographer is standing on the east hill to take this panorama shot of the town, looking west. On the left is the county building, with several businesses and homes visible on the right side of Pine Street. The hill in the middle of Pine Street would later be leveled. (Courtesy of Albert "Sunny" and Fanny Korfanta.)

The second two-story building in Pinedale, pictured here, was the Masonic Temple, built in 1928 and home to Franklin Lodge 31 A.F. and A.M. This building, located on the southeast corner of Tyler Avenue and Magnolia Street, was built by the Wilson brothers. The group was organized in 1911 and originally met in the Woodman Hall. (Courtesy of Sublette County Historical Society.)

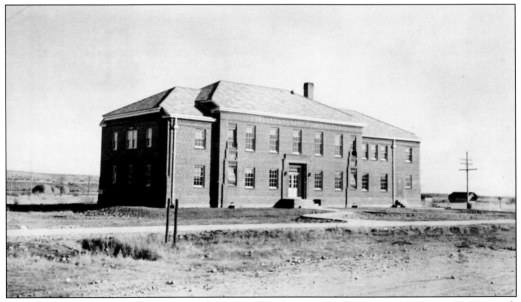

The Sublette County building is seen here shortly after its completion in 1931. Louis H. Hennick had donated the land for the site. The two-story building, a modified Colonial design, housed the county courtroom, judge's chamber, jury room, and county attorney and clerk of court offices. The sheriff, treasurer, and assessor's offices were also located here, along with the jail. (Courtesy of the Sublette County Historical Society.)

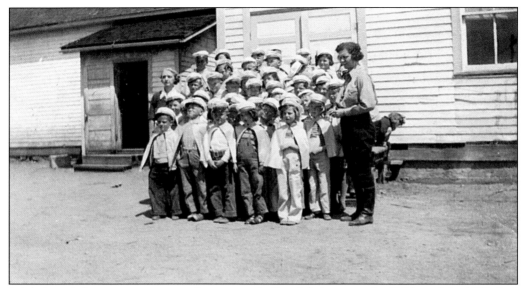

It is believed that every youngster who grew up in Pinedale between the 1930s and the 1950s had Madge Funk for a teacher. Well remembered for her musical training, Funk is seen here during the 1930s in front of the schoolhouse with her young rhythm band, in costumes. (Courtesy of Ralph and Charlotte Faler.)

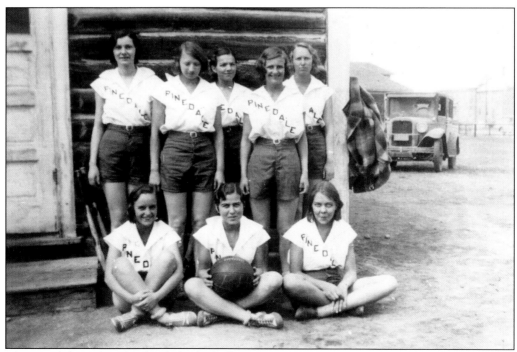

The Pinedale High School girls' basketball team is pictured here in 1932. Pictured are, from left to right, (sitting) Nadine Mortimer, June Healey, and Rita Faler; (standing) Alice Sargent, Ruth Jones, Eunice Healey, Eloise Westley, and Francis Bloom. (Courtesy of Erma Shriver.)

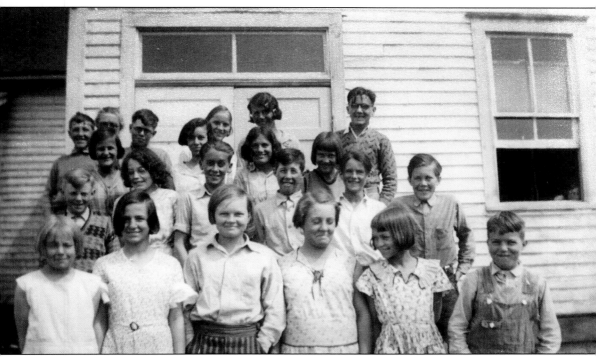

Young adolescents appear mischievous and happy in this class photograph. Standing in front of the Pinedale School building in the spring of 1932, their teacher, May Sommers, is in the back row. Students came from the Swartz, Clark, Rahm, Cantleberry, Westley, Montimore, Nelson, Ervin, Adrey, Holt, Easton, Cooper, Dalley, Cantlin, and Healey families. (Courtesy of Erma Shriver.)

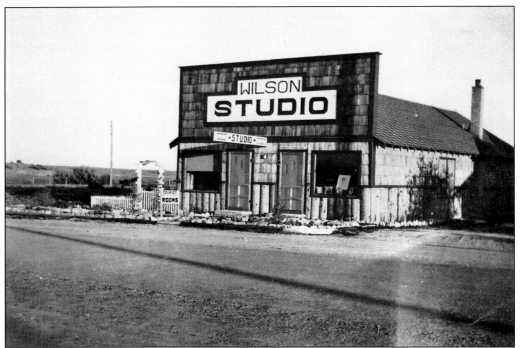

The Wilson Photo Studio, along with an apartment, was an addition to the family's soda pop factory. When the building contained only the soda pop factory, begun in 1927, the children referred to it as the "Pop House." Barrels of unmixed soda pop hung from the ceiling on chains. The children would "ride" the barrels, swinging back and forth until the ingredients were thoroughly blended. (Courtesy of David Takacs.)

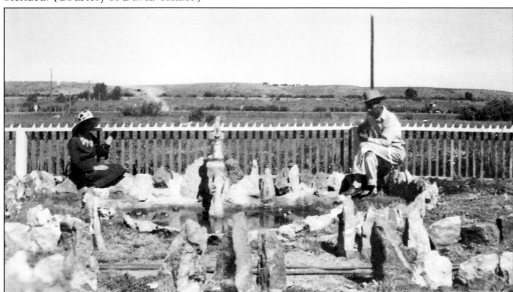

Alyna (left) and Dave Wilson enjoy their "rock garden" behind the Wilson Photo Studio and their home in 1937. Their proud garden creation worked well for the short summers and high altitude. (Courtesy of Dave Takacs.)

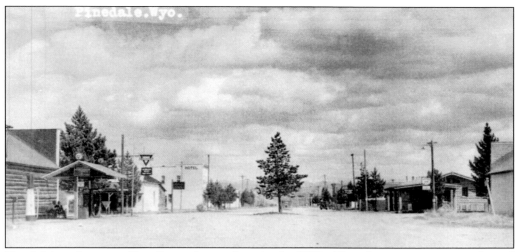

Pinedale's main street, Pine Street, is seen here in the 1930s. Note the many pine trees planted throughout town by volunteers under the leadership of C. C. Feltner, including the landmark tree in the middle of Pine Street. The Wyoming Highway Department permanently removed the tree in the middle of the street when the road was paved in the late 1950s, but a few cars almost removed it several times prior. (Courtesy of Sublette County Historical Society.)

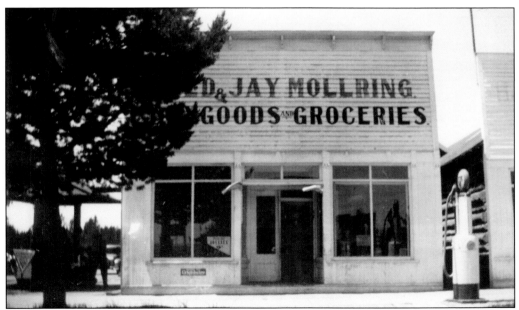

Fred and Jay Mollring opened their Pioneer Pinedale General Store in the early 1920s after buying out Jones, Son, and Company. From groceries to dry goods and clothing, the Mollring store also sold ranch equipment and supplies, hoping cattle prices would be good enough for ranchers to pay off their charged goods once a year. (Courtesy of Paul Allen.)

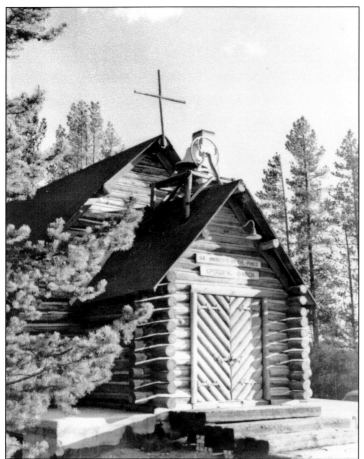

The cornerstone for St. Andrew's in the Pines Episcopal Church was laid on May 4, 1938. The log structure was located on the south side of Pine Street, along the banks of Pine Creek. In 1953, the whole building was lifted and placed on top of a basement, adding space for church work and socialization. When the congregation outgrew this building, it was moved to private property across the street. (Courtesy of Paul Allen.)

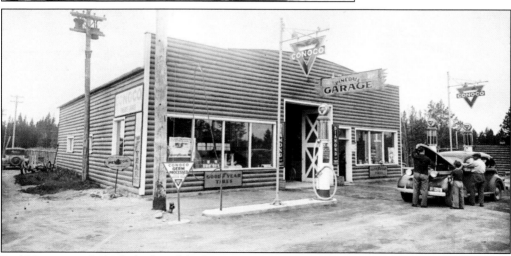

Paul Hagenstein Sr. built the Pinedale Garage in 1935 and ran the business until 1944. The business offered Conoco gasoline, Pennzoil, and Goodyear tires. The building stands on the southeast corner of Pine Street and Lake Avenue. (Courtesy of Sublette County Historical Society.)

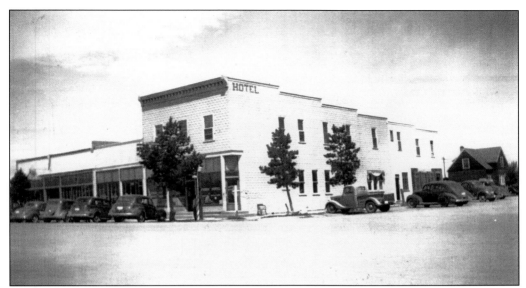

The Fardy Hotel, originally called the Pines Hotel, is seen here in the 1940s after a major expansion. Located on the corner of Pine Street and Maybel Avenue, the original hotel was enlarged to include a restaurant, bar, barbershop, and offices. It housed numerous travelers as well as ranch children who attended high school but lived too far away for a daily commute to school. (Courtesy of Sublette County Historical Society.)

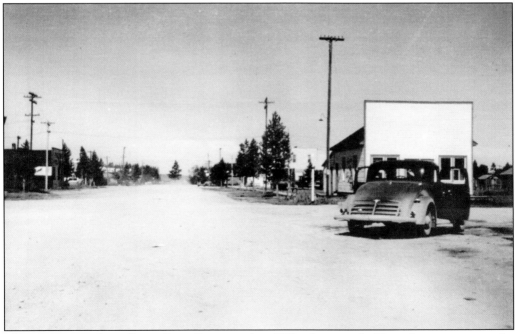

There is not much traffic on Pine Street in this 1930s photograph. Note the pine tree in the middle of the street at the top of the street's knoll (the street would later be leveled out). The car on the right is parked in front of the Pinedale Roundup Building on Tyler Street. (Courtesy of Ann Chambers Noble.)

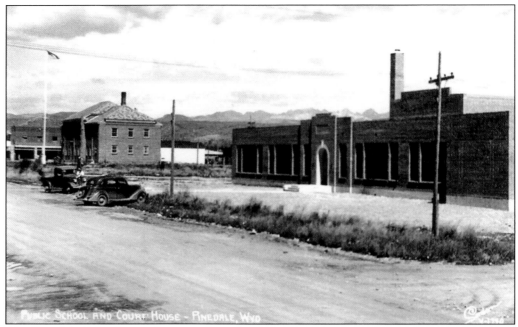

The Pinedale School, seen here on the right, housed all the grades, from elementary to high school, when it opened in 1937. It was only the grade school by the time it closed in 1987; the high school moved to a new building in the 1960s. The old school was built on property donated by Louis H. Hennick and was located south of the courthouse, pictured on the left. (Courtesy of Paul Hagenstein.)

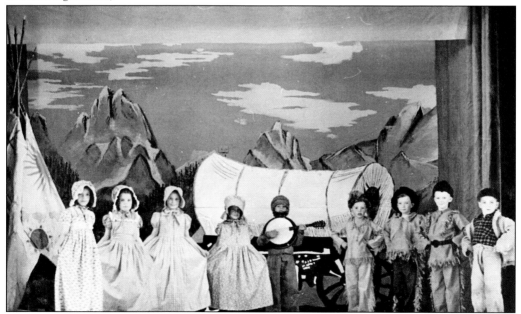

The Pinedale second graders in 1940 are posed here for their concert featuring the Virginia reel. Their proud teacher, Marilyn Summers Jensen, was a lifetime teacher and resident. (Courtesy of Ralph and Charlotte Faler.)

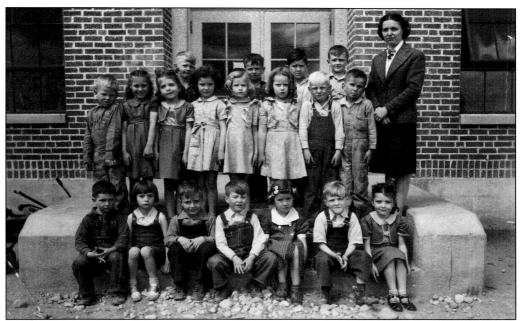

Posing on the front steps of the schoolhouse is a Pinedale elementary class in 1940–1941. With improved roads and modes of transportation, some rural school districts were closing. The Daniel, Cora, Boulder, Eastfork, Bondurant, and Bronx school districts began busing their children to Pinedale for school starting in the 1940s. (Courtesy of Paul Allen.)

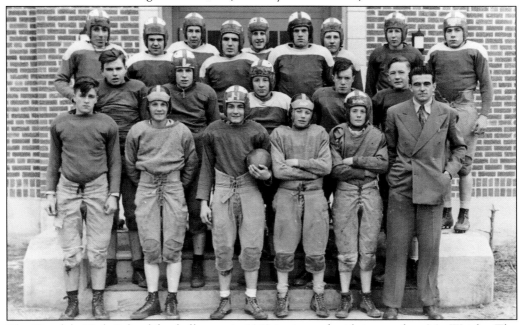

The Pinedale High School football team in 1942 is pictured with its coach, a Mr. Wright. The Wranglers won 7 out of 10 games that year, their most successful season during the four years Pinedale participated in the sport. The boys played teams from Reliance, Diamondville, Jackson, Eden, and Big Piney. (Courtesy of Mike and Ruth Noble.)

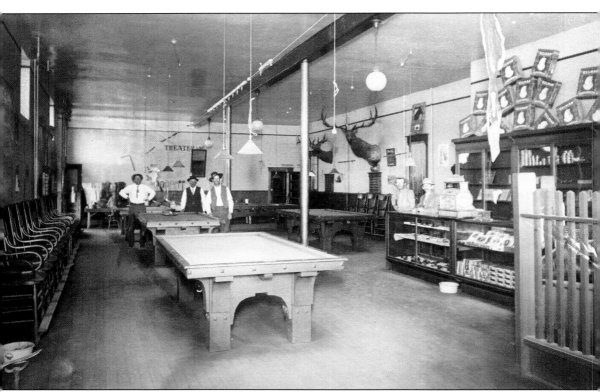

Pool halls were popular gathering places in Pinedale. Early residents Ralph Faler and the Hoff brothers are among those seen here in the Bayer Pool Hall on Franklin Street. Owner Allie Bayer offered soft drinks and billiards, but not alcohol, from 1920 until 1933 due to Prohibition. Gambling, however, was legal throughout this time. (Courtesy of Harold Faler.)

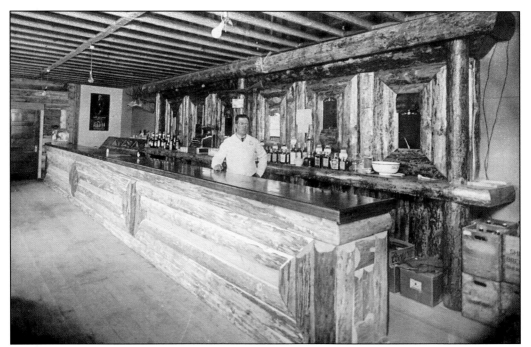

Lester Faler stands behind the bar at his business, the MF Corral, named for his partner Judson (Mac) McCormick and himself. The MF Corral originally opened in the old Wilson Hall on Pine Street in the 1930s, as seen in this photograph. It would later move to a new location farther west along Pine Street. (Courtesy of Ralph and Charlotte Faler.)

Judson (Mac) McCormick stands on the left next to his longtime business partner, Lester Faler. The two men, seen here in their older years, ran one of Pinedale's most popular gathering places, the MF Corral. The bar was in business on Pine Street for decades. (Courtesy of Ralph and Charlotte Faler.)

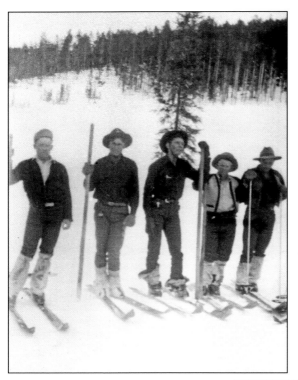

The long winters have never been a deterrent for enjoying the great outdoors. Pictured here are early downhill skiers. After hiking up the mountain, they used a single pole to steer and slow down during their descent. From left to right are unidentified, Ed Hicks, Sam Hicks, Buzz Farwell, and Jack Hicks. (Courtesy of Swede McAlister and Jonita Sommers.)

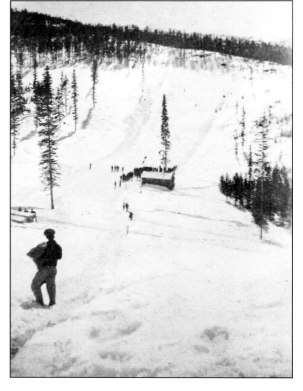

On January 5, 1940, the Surveyor Park Ski Area officially opened 12 miles north of Pinedale at Fortification Mountain. Skiers were pulled to the top of the hill, as shown here, by a cable tow powered by a Chevrolet motor mounted on a concrete slab. The local Civilian Conservation Corps, operating from a camp near the ski hill in the 1930s, cleared the trees from the hillside for the ski runs. (Courtesy of David Takacs.)

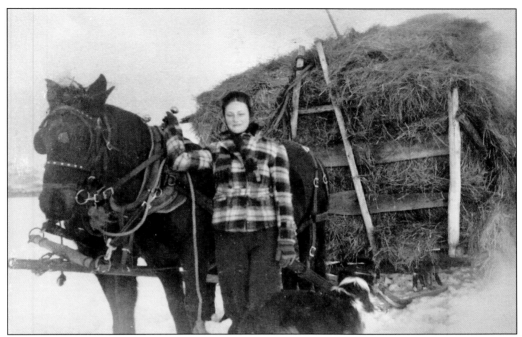

Frances Wilson stands beside a feed horse on the Eklund Ranch, east of Pinedale. The feed sleigh could carry up to a ton of hay, which was scattered on the snow for the cattle and horses. The hay first had to be loaded onto the sleigh, then off again around the field, all by hand with a pitchfork. (Courtesy of Dave Takacs.)

Jack Funk is seen here at Christmas enjoying a drink in the company of his canine friend, Rusty, in the 1930s. Funk, a government predator trapper, moved to Pinedale in 1929 or 1930. It is believed that he was the model for the main character in Zane Grey's book *Man of the Forest*. (Courtesy of Paul Allen.)

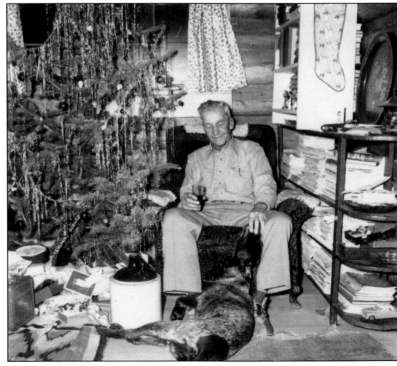

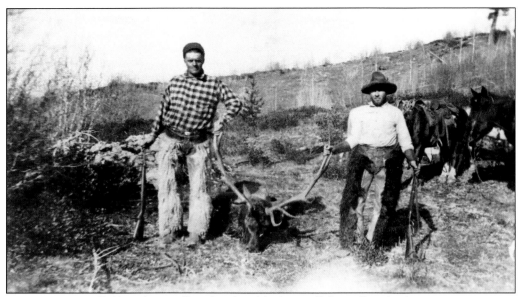

James Jorgensen (left) and Carroll Richard Noble show off their elk. This hunting trip in 1928 was "on the Rim," or the area near Fall Creek north of Pinedale, which boasted a well-known elk habitat. Note the angora chaps on both hunters. (Courtesy of Pat and Ben Pearson.)

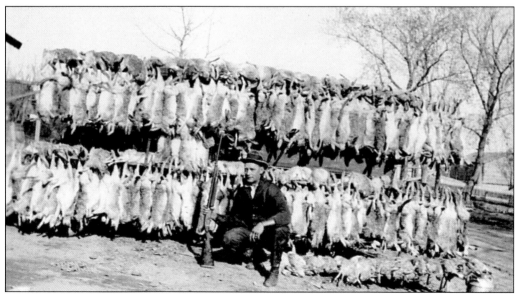

A local predator hunter displays his jackrabbit harvest in the 1940s. Residents were known to use the meat and pelts from these hunts. (Courtesy of Ralph and Charlotte Faler.)

This elderly fisherman caught his giant trout on a fly rod near Pinedale. Fishing has always been a popular sport in the area, and the catch has often been a welcome meal. (Courtesy of Sublette County Historical Society.)

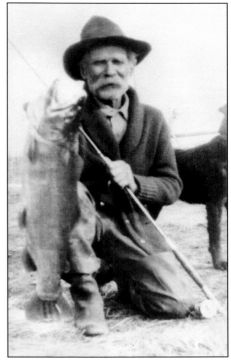

Val McAlister, pictured below on the left with an unidentified friend, shows off the day's catch. The successful Pinedale fishermen are at Shoal Lake, a popular fishing place for locals. (Courtesy of Ralph and Charlotte Faler.)

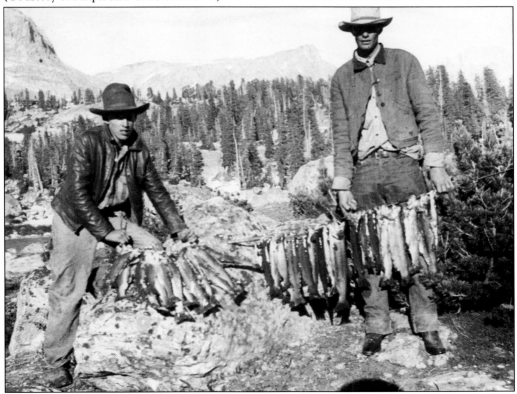

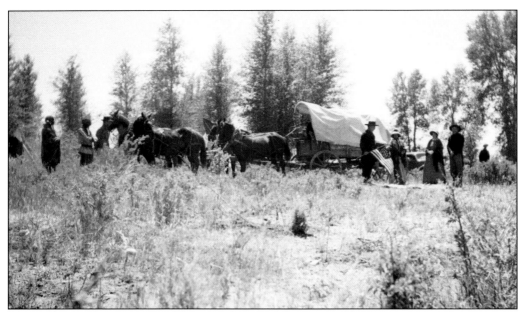

The Sublette County Historical Society sponsored the first Rendezvous reenactment in 1936 to commemorate the 100th anniversary of the original fur-trade rendezvous held near Pinedale. The early reenactments, such as the one photographed here, were held in Daniel, west of Pinedale, near the original rendezvous site. (Courtesy of Sublette County Historical Society.)

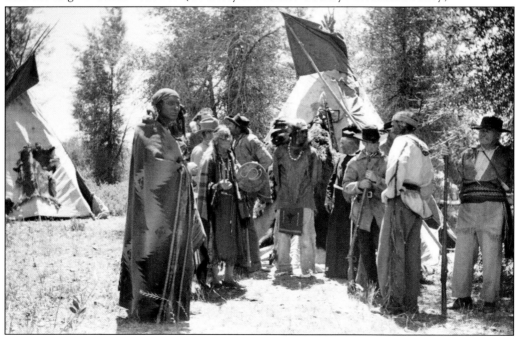

Fur-trade rendezvous reenactments were elaborate affairs, complete with teepees and two- and four-horse Conestoga wagons. Actors donned costumes depicting the mountain men, Native Americans, and early white missionaries. Pictured here is an early reenactment at the Daniel Rendezvous grounds. (Courtesy of Sublette County Historical Society.)

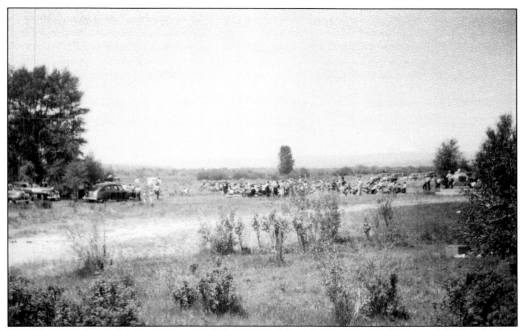

Daniel, west of Pinedale, was the site of the original Rendezvous in the 1820s and 1830s; the last one was held in 1840. The actors here are performing on the same ground where the original events took place more than 100 years before. (Courtesy of Ralph and Charlotte Faler.)

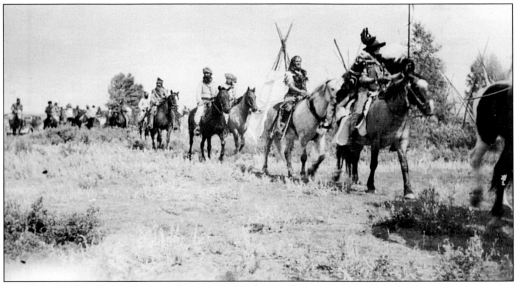

Pinedale residents and area ranchers were the featured actors in the Rendezvous reenactments. In addition to providing their own horses, they made their own costumes. Photographed here is the cast proceeding to their performance. (Courtesy of Ralph and Charlotte Faler.)

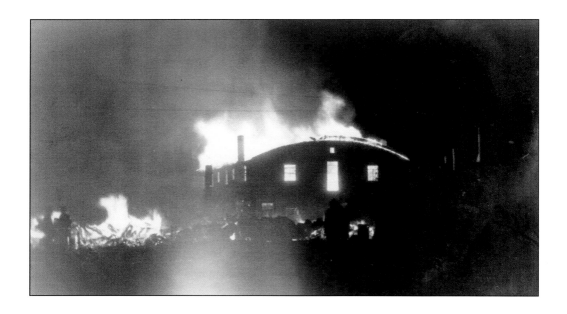

On the night of March 11, 1939, a fire started at the Murphy Warehouse and Lumber Company. When it was over, the new drugstore, the Elk Café, and the power plant had all gone up in flames, along with the warehouse. Fire suppression was hampered by frozen fire hydrants. It was the worst fire in Pinedale's history. (Both, courtesy of Albert "Sunny" and Fanny Korfanta.)

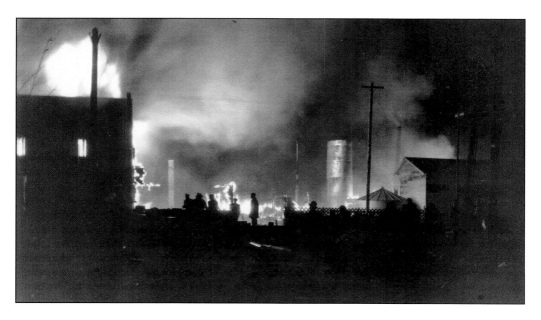

Four

SERVING OUR COUNTRY

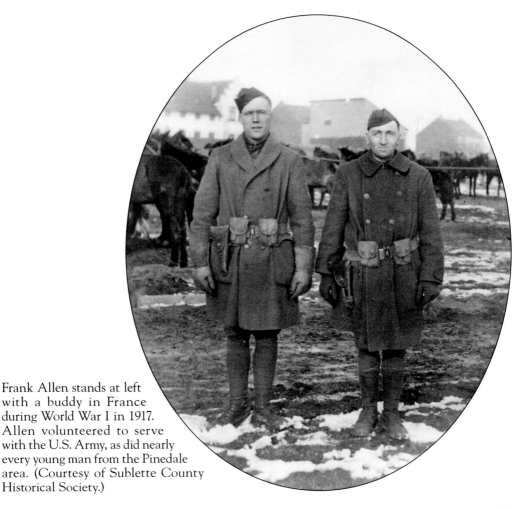

Frank Allen stands at left
with a buddy in France
during World War I in 1917.
Allen volunteered to serve
with the U.S. Army, as did nearly
every young man from the Pinedale
area. (Courtesy of Sublette County
Historical Society.)

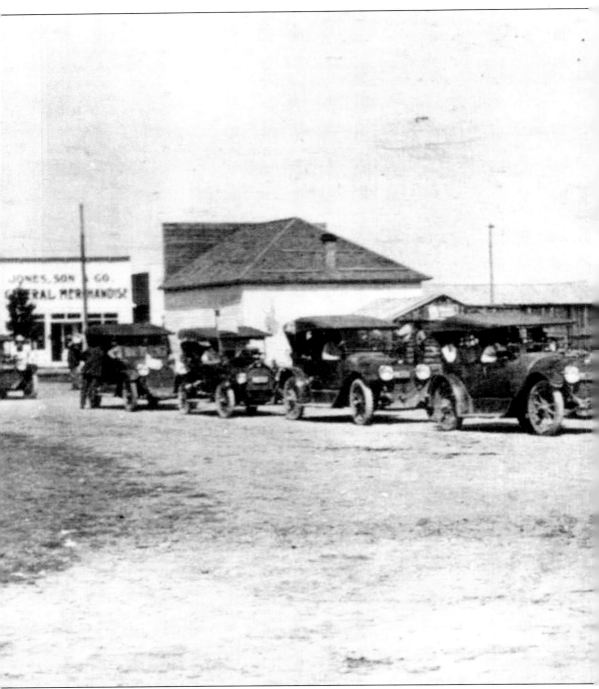

Recruitment for local soldiers began in Pinedale in April 1917 immediately after America's entrance into World War I, or the Great War as it was referred to at the time. In a front-page news story, Capt. H. H. Waugh of Kemmerer called for volunteers and the formation of a machine gun company in this section of the state. It would be known as the Machine Gun Company, 3rd Wyoming Infantry. On August 3, 1917, a caravan of automobiles, pictured here, was secured to

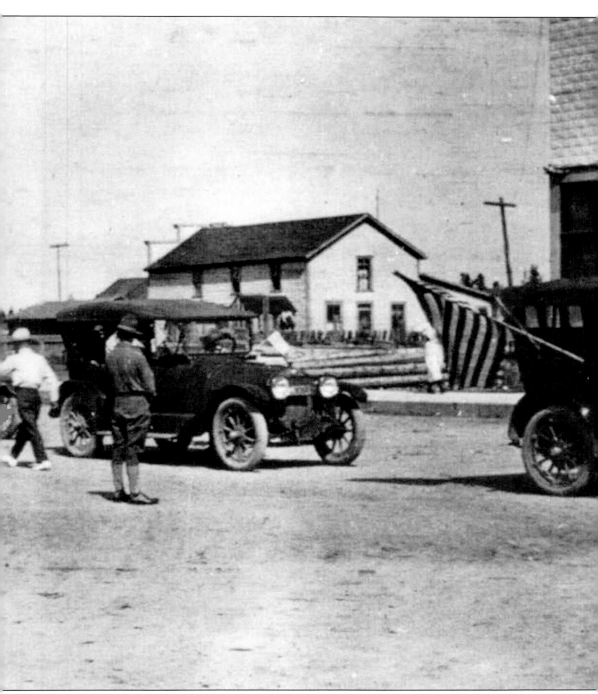

take the young volunteers to Rock Springs, where they would catch the train to Cheyenne and then report for duty. The *Pinedale Roundup* reported of the departing event: "They were assigned to the capacity of each car and the good byes were said with many a broken voice, and a touch of sadness overspread the populace who had turned out to wish them God speed and a safe return as the order to proceed came." (Courtesy of Sublette County Historical Society.)

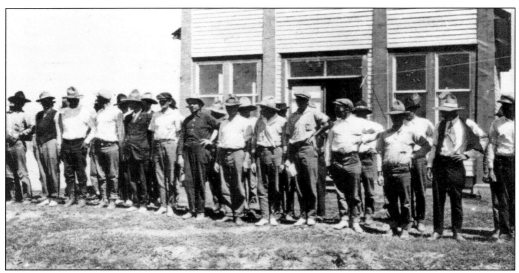

Young volunteers lined up in front of town hall prior to departing for service in the U.S. Army in 1917. Pinedale was the headquarters for the machine gun company formed from volunteers in the western part of Wyoming. (Courtesy of Sublette County Historical Society.)

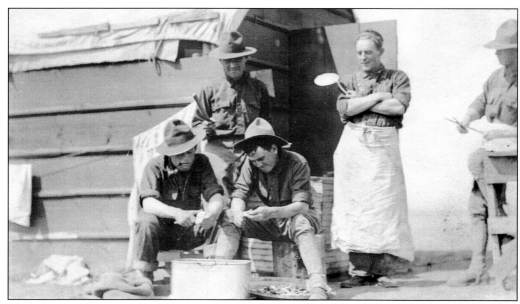

This photograph, printed on a postcard, is dated August 26, 1917, and was sent by Lt. Jess Miller to Charles F. Patterson, Pinedale's mayor and editor of the *Pinedale Roundup*, after Miller's arrival at Fort D. A. Russell in Cheyenne. The message reads, in part, "Dear Friend Charlie—We are getting along nicely all the men coming 'out of it' in fine shape." (Courtesy of Paul Allen.)

Pinedale native Sidney Edwards was killed in a hospital in France when an airplane shelled the building on July 15, 1918. He was in the hospital recovering from appendicitis. His body was exhumed from its initial grave in France and was brought back to Pinedale for interment in the Pinedale Cemetery in August 1921. (Courtesy of Helen Stout.)

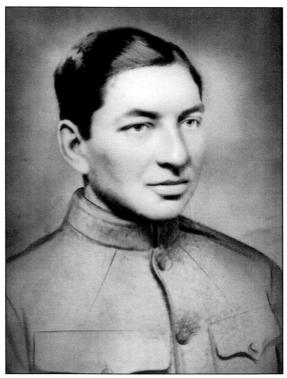

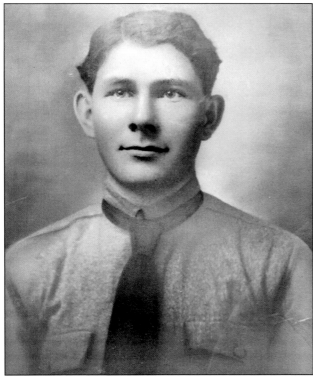

The last passage in Clifford Phillip's diary, which he faithfully kept throughout the war, was written by his brother Mason. Dated July 28, 1918, it read: "Clifford was killed by sniper." Clifford, pictured here, was buried in France. Pinedale's Phillips-Edwards American Legion Post 47 was named in honor of the two local men who lost their lives during World War I. (Courtesy of American Legion Post 47.)

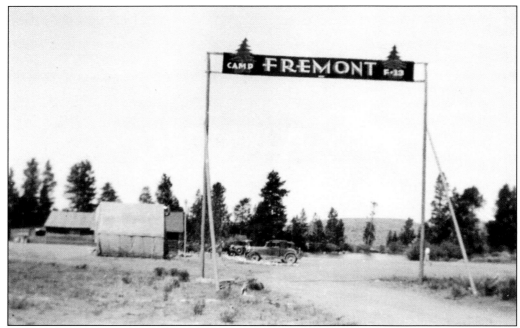

One of the most popular and successful New Deal programs during the Great Depression was the Civilian Conservation Corps (CCC), which combined work relief with the preservation of natural resources. One of the first CCC camps in the country was Camp Fremont (known as F-13), which opened in 1933 on the south shore of Fremont Lake. (Courtesy of Paul Allen.)

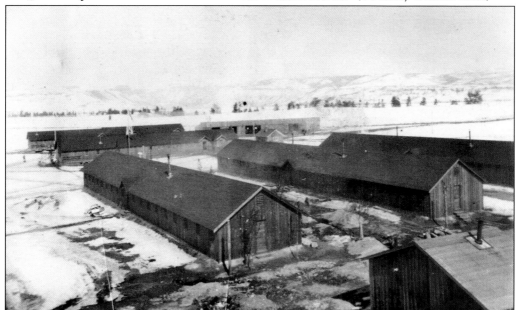

Civilian Conservation Corps recruits came to Pinedale from around the country and lived in army barracks that were quickly built. When the camp closed in 1942, these buildings would be relocated to Pinedale and the surrounding area after being sold for a nominal fee. (Courtesy of Sublette County Historical Society.)

Capt. Byron H. Lytle was one of several commanding officers at Camp Fremont. Under his charge during his years at Pinedale were hundreds of CCC recruits. (Courtesy of Sublette County Historical Society.)

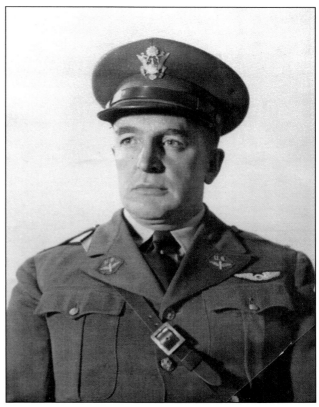

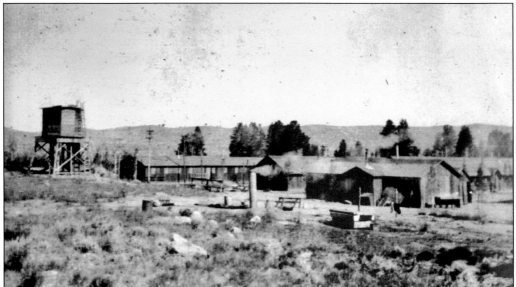

The water tower, shown on the left, supplied the mess hall and washrooms at Camp Fremont. The U.S. Army built and operated the Civilian Conservation Corps camps around the nation. Camp Fremont was one of more than 1,500 camps. By the end, more than 2.5 million men and 8,000 women were put to work. (Courtesy of Sublette County Historical Society.)

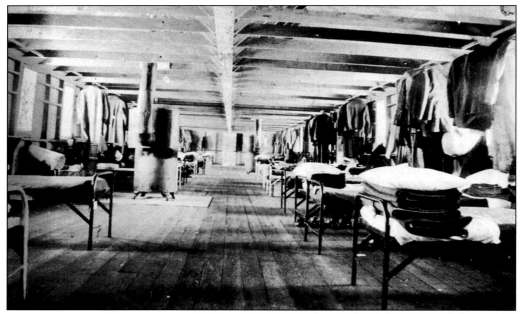

The inside of the army-style barrack at Camp Fremont is photographed above shortly before a visit from the commanding officer. (Courtesy of Sublette County Historical Society.)

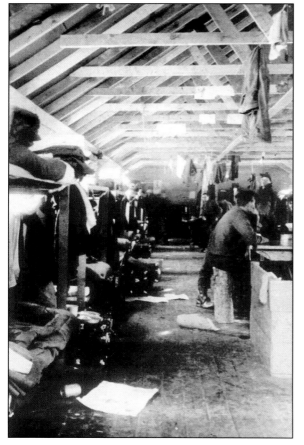

This photograph captured the inside of the barrack at Camp Fremont with no visit from the commanding officer scheduled in the near future. (Courtesy of Sublette County Historical Society.)

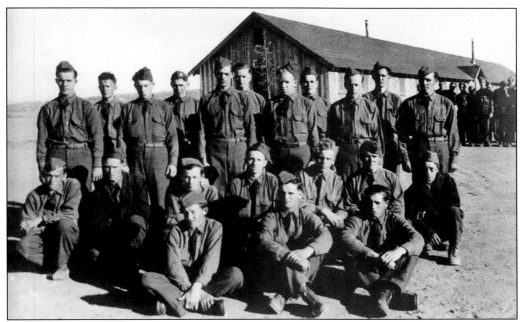

When the young men arrived, such as this group, mostly from Ohio, it was not uncommon for them to be overwhelmed by the higher altitude. Once the adjustment was made, they were put to hard work, which was extensive and varied, including insect control, building projects, stream improvement, and fighting forest fires. (Courtesy of Sublette County Historical Society.)

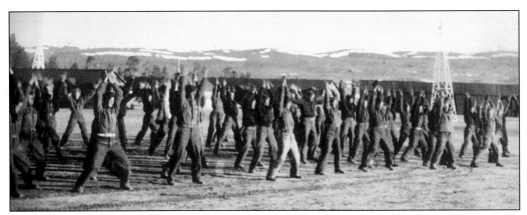

Part of their regular routine while at camp was staying fit with calisthenics. Many of the young recruits were from cities and had little or no experience with outdoor work. A Pinedale man hired to work as a foreman for the young recruits commented years later, "They were good kids, but dumb! They didn't know anything." Most had never held a shovel or ax before joining. (Courtesy of Sublette County Historical Society.)

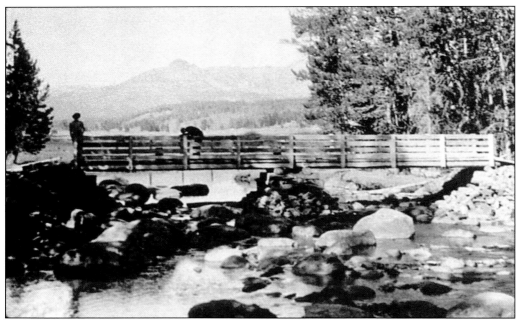

Assisting the agriculture industry was a CCC priority. Camp Fremont enrollees built stock bridges, such as this one, in the Wyoming National Forest. The CCC workers also constructed stock fences and holding pens in the forests. (Courtesy of Sublette County Historical Society.)

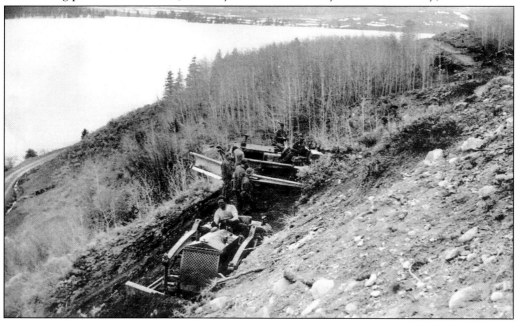

One of the larger projects was road building under the direction of Pinedale local Jack Funk. Pictured here are CCC enrollees building the road to Half Moon Lake from Pinedale. They constructed roads from Kendall to Green River Lake, from LaBarge to Star Valley, and one alongside Fremont Lake. They also improved Skyline Drive and the road from Pinedale to Big Piney. (Courtesy of Sublette County Historical Society.)

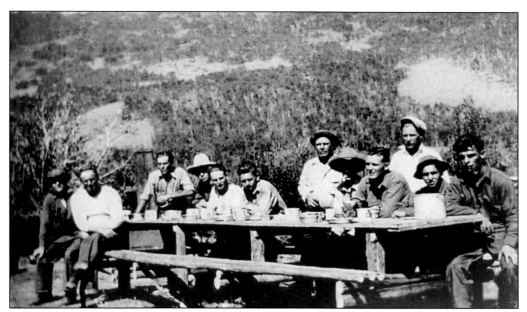

Recruits at Willow Creek are taking a lunch break. CCC enrollees working from Camp Fremont came from New York, California, Ohio, Virginia, Illinois, Kentucky, and Wyoming. Many enrollees at Camp Fremont developed a lasting love for the country, making the area a vacation destination throughout their lives because of their CCC experience. (Courtesy of Sublette County Historical Society.)

Construction work completed by Camp Fremont recruits included repairing or building telephone lines, electrical lines, drift fences, and an office building on south Franklin Street in Pinedale in 1933. This would be used as the headquarters for the Fremont Ranger District of the Wyoming National Forest. The young men also built the ranger station at Kendall, pictured here, and at Willow Creek. (Courtesy of Sublette County Historical Society.)

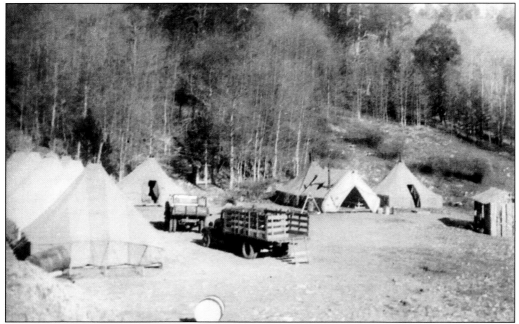

Several spike camps worked out of Camp Fremont, including Big Piney, Dutch Joe, Newfork, Green River, Cottonwood Creek, Snider Basin, LaBarge Creek, and Granite Creek. The spike camps, photographed here, were temporary and enabled workers to be closer to their job sites. (Courtesy of Sublette County Historical Society.)

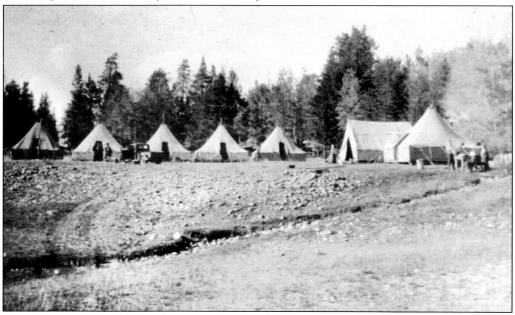

Camp Fremont's Dutch Joe spike camp, photographed here, was near the Utah/Wyoming border, indicating how far the Pinedale headquarters extended its work. Projects undertaken by this camp included construction of stock driveways, cattle bridges, and corrals for sheep moving between national forests and private land. (Courtesy of Sublette County Historical Society.)

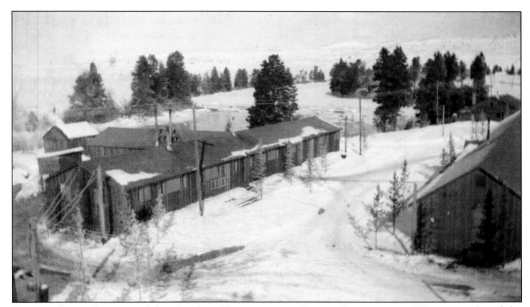

During the early years of the Civilian Conservation Corps, the camps in Wyoming closed for the harsh winters, and enrollees were sent to Oregon and California to work. By 1935, however, men were working year-round at Camp Fremont, earning bragging rights when they did not miss a day's work despite the cold. Photographed here is Camp Fremont operating during the winter. (Courtesy of Sublette County Historical Society.)

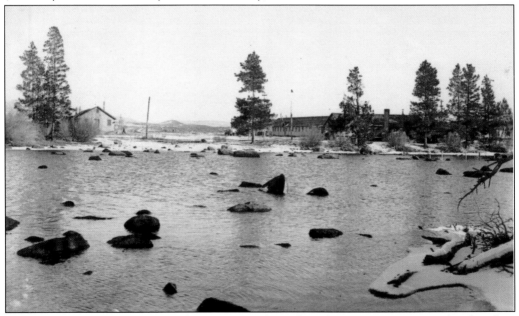

Camp Fremont is seen here from the Fremont Lake outlet. The CCC recruits completed work at the lake, including building campgrounds, a dock, and a boathouse for the U.S. Forest Service. A dock at the inlet on the upper end of the lake was never finished due to the camp's sudden closure in 1942. Recruits also constructed fish-rearing ponds at Newfork and Fremont Lakes, and then planted the fish in area lakes. (Courtesy of Ralph Wenz.)

Aerial Photographer, Boston, Mass. '43

With the bombing of Pearl Harbor on December 7, 1941, the United States suddenly entered World War II. Young men and women from across the country put on military uniforms and served their country around the world. Young Pinedale residents, such as Harold Faler, photographed at left, were among those marching off to war. Faler served in the U.S. Navy. (Courtesy of Sublette County Historical Society.)

In this photograph below, Pinedale natives J. D. Wilson (left) and Clem "Bud" Skinner are enjoying some rest and relaxation while in the service. Wilson writes, "Clem and I at "Sweets" in Oakland. I wish he was here to go on more of those liberties." Pinedale's servicemen kept in touch with newsletters written, printed, and mailed by school superintendent Lawrence "Pops" Trenary and Lillian Allen. (Courtesy of Sublette County Historical Society.)

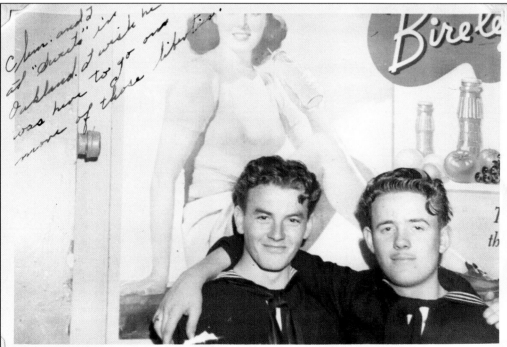

Later World War II observances in Pinedale would be enhanced by personal stories from residents who were present at historic events. Navy officer Jeff Kaul, pictured here, and army private Bruz (Starling Oris) Bryant were at Pearl Harbor on the fateful morning of December 7, 1941. Hayden H. Huston was a chief petty officer who witnessed the surrender of the Japanese on August 14, 1945, marking the end of hostilities. (Courtesy of Wilma Kaul.)

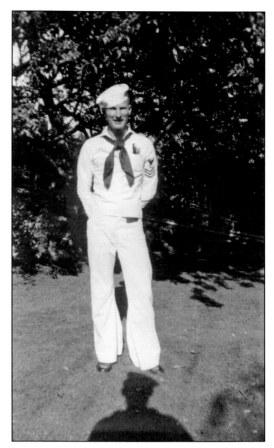

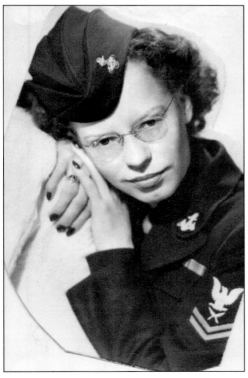

World War II was the first war that encouraged women to join the military. Young women from Pinedale answered the call, including Wilma Kaul, who served as a WAVE (Women Accepted for Volunteer Emergency Service), the women's branch of the navy. She would later serve as the Pinedale selective service clerk during the Vietnam War. (Courtesy of Wilma Kaul.)

Pinedale resident S.Sgt. Ralph Wenz, pictured here, was killed in the line of duty when his bomber crashed in the wilds of Alaska on December 21, 1943. Pinedale's municipal airport was named in his memory on Memorial Day 1949. (Courtesy of Wenz family.)

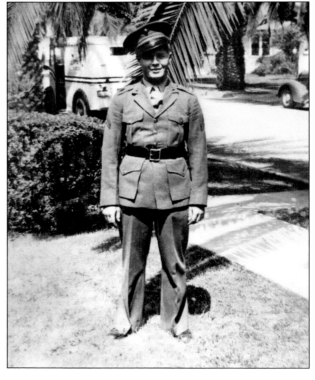

S.Sgt. Boyd Skinner was killed in action at Iwo Jima on March 10, 1945. The Pinedale native, pictured here, enlisted in the marines in July 1940, following his graduation from Pinedale High School with the class of 1940. The town park at the south end of Franklin Avenue is dedicated to him. (Courtesy of Sublette County Historical Society.)

Five

THE TOWN MODERNIZES

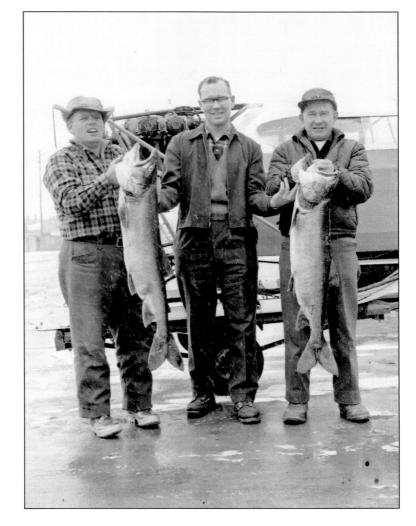

Fremont Lake is famous for its large mackinaw fish. From left to right, fishermen Monte Wight, George Nugent, and Tom Astle show off their mackinaw catch on February 17, 1963. The gentlemen are standing in front of a snow plane, commonly used for ice fishing. Snow planes, so called because of the large propeller, were earthbound, slowly cruising over the snow on large metal skis. (Courtesy of Paul Allen.)

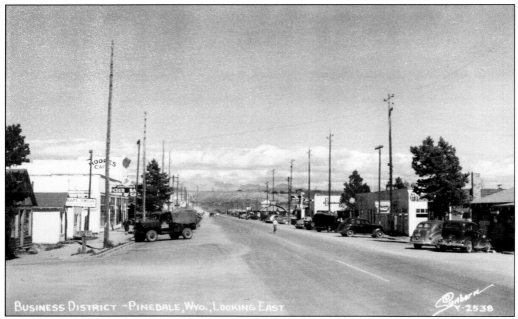

Harold Sanborn captured this picture of Pinedale's business district, looking east down Pine Street, sometime in the late 1940s. Originally, the town's business district was on Franklin Avenue, but by the 1920s, it had shifted to Pine Street. The main highway into Pinedale was changed from Franklin Avenue to Pine Street, leading many businesses to change their locations, too. (Courtesy of Carol Artes.)

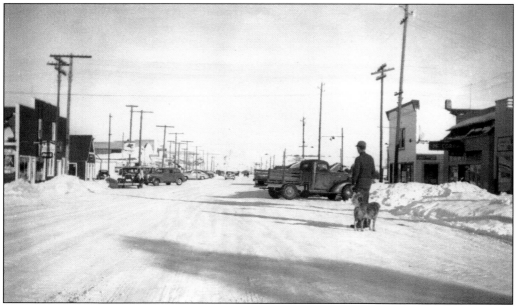

The winters have always been long in Pinedale, but the heaviest snows on record for the area came during the 1940s. Photographed here is a local looking east down Pine Street one winter afternoon in the late 1940s. Note the snowbanks along the street sides. It has always been a challenge keeping the streets clear of snow. (Courtesy of Paul Allen.)

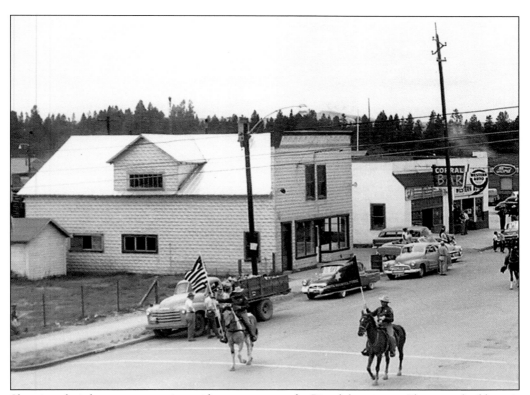

Showing their hometown patriot pride was common for Pinedale citizens. Photographed here is a 1950s parade down Pine Street with the lead rider carrying the American flag. Parades were common in town, especially on the Fourth of July. (Courtesy of Paul Allen.)

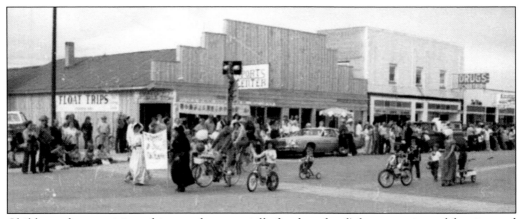

Children often participated in parades, especially for the school's homecoming celebration and during Rendezvous. This group of young people is heading down Pine Street for Rendezvous during the 1960s. Note the many bikes replacing the horses common in earlier parades. (Courtesy of Paul Allen.)

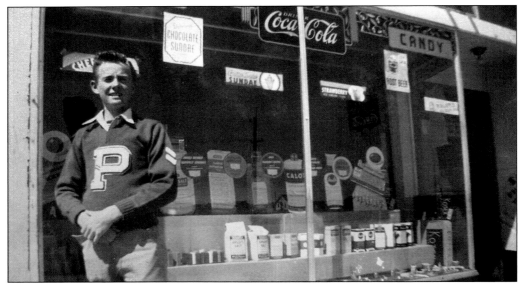

Bud Skinner proudly shows off his Pinedale letterman's sweater as he stands in front of the Pinedale Drug Store in the 1950s. Athletes earned the sweater for their team participation. The drugstore was a popular place for high school students to come for lunch, which was usually a milk shake. (Courtesy of David Takacs.)

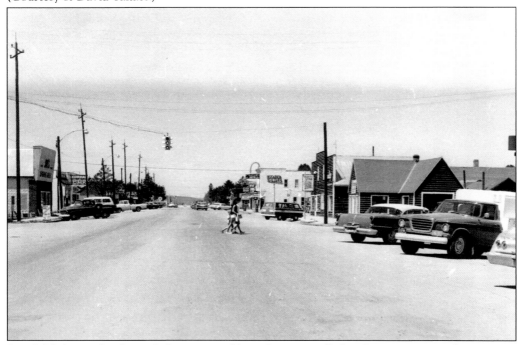

Pinedale's first and only stoplight is pictured here. It was installed at the intersection of Pine Street and Tyler Avenue in 1960. The location was chosen to assist children crossing Pine Street from the school on south Tyler Avenue. After only a short time, the stoplight was deemed unnecessary and was removed. It was placed in storage, where it remained for decades. (Courtesy of Sublette County Historical Society.)

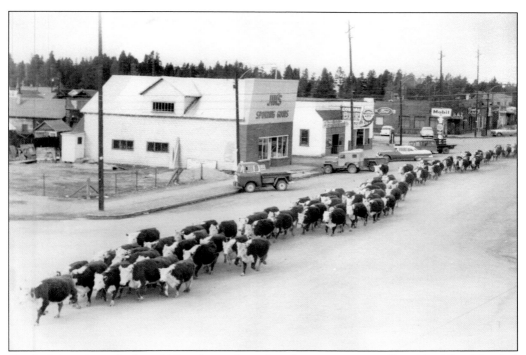

Cattle drives through the middle of town have long been common in Pinedale. This Hereford cattle herd is heading east along Pine Street around 1960. While amusing for tourists, the locals were sometimes inconvenienced by the traffic holdup. (Courtesy of Paul Allen.)

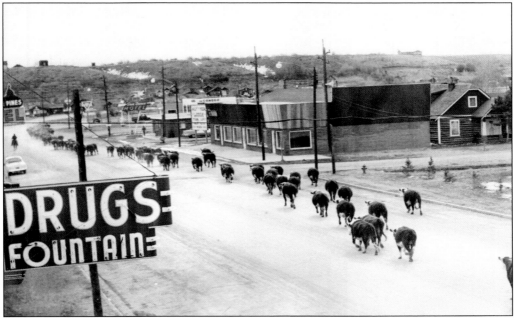

The Hereford cattle drive continues through town, heading east, around 1960. Using roads such as Pine Street and the highways worked well for cowboys moving cattle. With no feed available on the roads, the cattle were more likely to keep moving. (Courtesy of Paul Allen.)

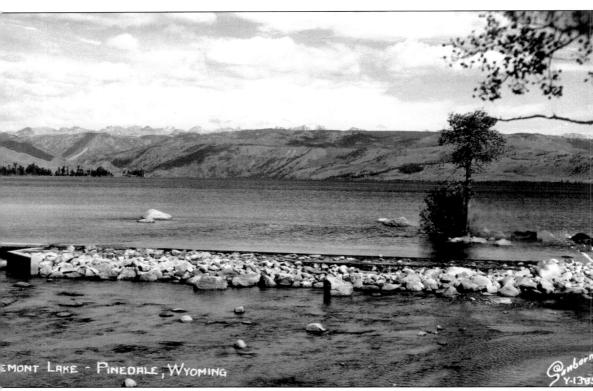

EMONT LAKE - PINEDALE, WYOMING

Fremont Lake was a favorite scenic subject for photographer Harold Sanborn. In this picture, he captures the lake from the outlet on the south side in the 1930s. In the foreground, the rock piles are at the dam. Peaking over the lake ridge in the background are the Wind River Mountains. (Courtesy of Albert "Sunny" and Fanny Korfanta.)

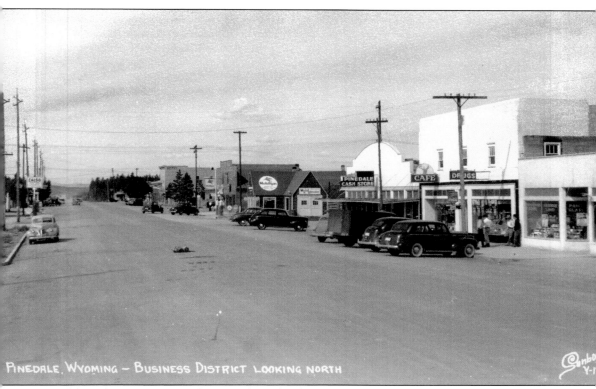

PINEDALE, WYOMING – BUSINESS DISTRICT LOOKING NORTH

Harold Sanborn, a Denver photographer who documented Colorado and Wyoming, came to Pinedale every decade of his career from the 1920s until the 1960s. Many of his photographs were made into postcards. Sanborn captures post–World War II Pinedale in this photograph of Pine Street, looking west. The businesses on the north side of the street are, from left to right, the Fardy Hotel, Faler's Market, Mobilgas, Pinedale Cash Store, Elks Café, and Pinedale Drug Store. (Courtesy of Albert "Sunny" and Fanny Korfanta.)

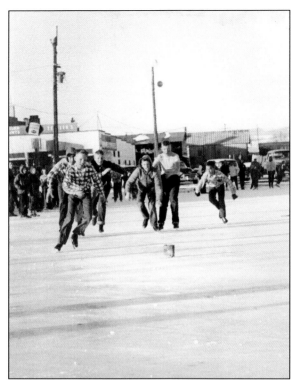

Ice-skating races for boys and girls were held at the public rink located east of the Sublette County building throughout the 1950s, often as part of the winter carnival. Racers dashed madly around the track, which was marked off with coffee cans set up on the ice. Silver dollars were given as prizes. (Courtesy of Paul Allen Collection.)

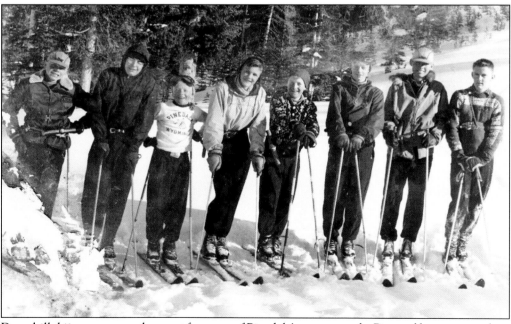

Downhill skiing was a popular sport for many of Pinedale's young people. Pictured here are members of the Pinedale Ski Club, a group that was active throughout the 1960s. In addition to recreational skiing, the club was active with hosting ski races in which skiers were invited from other Wyoming towns as well as Utah and Idaho. (Courtesy of Sublette County Historical Society.)

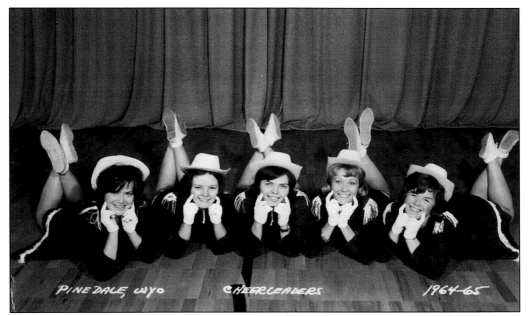

The Pinedale High School cheerleaders for 1964–1965 pose for their team picture. Their uniforms reflected the Western cowboy culture of the town. (Courtesy Ralph and Charlotte Faler.)

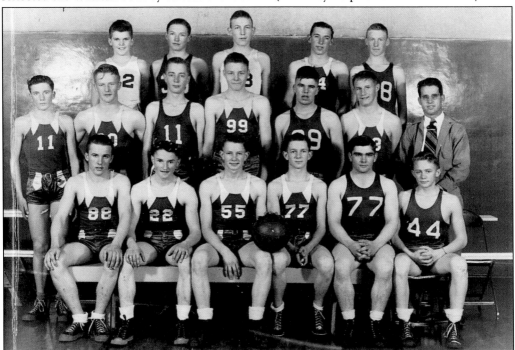

The 1947 Pinedale High School basketball team poses for their team photograph. Their coach, Albert "Sunny" Korfanta, stands on the right in the second row. The team played 8 conference and 10 nonconference games before 4 district competitions. Their 3 state tournament competitions were against Tensleep, Moorcroft, and Glenrock. (Courtesy Ralph and Charlotte Faler.)

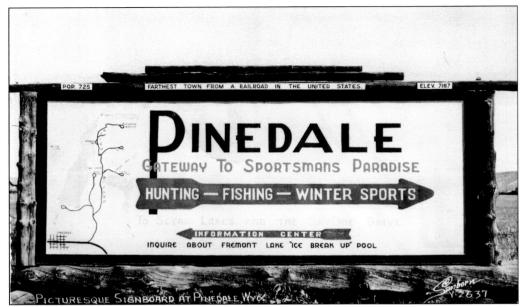

Harold Sanborn photographed this "Picturesque Signboard at Pinedale, Wyoming" on one of his trips through the area. The town's business people recognized the importance of tourists for their economy and worked diligently throughout the decades to promote the area. A tourist information center opened on June 1, 1958. The main arrow pointing to "Hunting—Fishing—Water Sports" is directing traffic to Fremont Lake. (Courtesy of Sublette County Historical Society.)

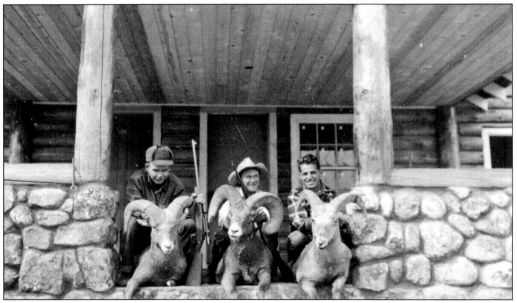

Hunting mountain sheep is most challenging, especially with the animals' ability to climb quickly up rocky slopes, making them difficult to catch. Despite this challenge, these three hunters were successful in 1950. From left to right are Mike Noble, Morris Nesmith, and Albert "Sunny" Korfanta with their mountain sheep on the porch at the Noble Ranch. (Courtesy of Mike and Ruth Noble.)

Fishing is likely the most favorite outdoor pastime for Pinedale residents and visitors. Pictured at right are three generations of Kauls. From left to right are Floyd Jr., Floyd Sr., and young Alan with their day's catch from a local stream in the late 1950s. (Courtesy of Wilma Kaul.)

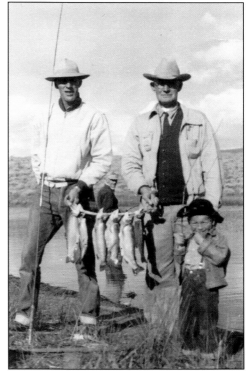

Local geese hunters show off their success in this early 1960s photograph below. The hunters are, from left to right, Wyoming Game and Fish game warden Duane Hyde, Bill Faler, Tom Astle, and Ralph Faler. (Courtesy of Ralph and Charlotte Faler.)

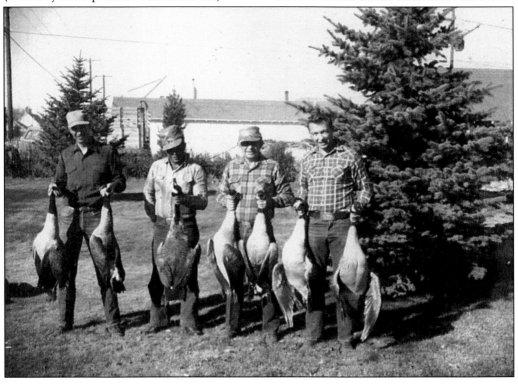

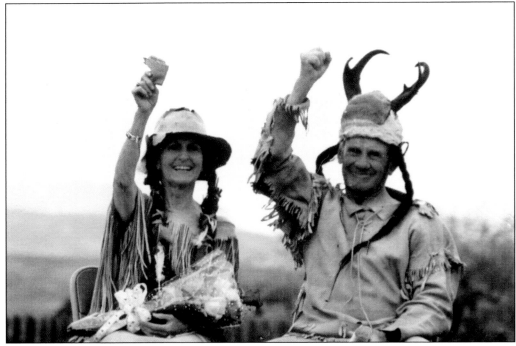

Bette and Paul Hagenstein raise their hands in cheer at a Rendezvous reenactment. The Hagensteins were being recognized for their years of service to the Sublette County Historical Society and the Rendezvous celebration. The success of Rendezvous in Pinedale for decades was the result of people like the Hagensteins who donated hours of their time and talent. (Courtesy of Paul and Bette Hagenstein.)

The Mad Hatters sang at numerous events around town throughout the 1960s, including weddings, funerals, Rendezvous, and banquets. Pictured here from left to right are members Donna Sievers, Miriam Kerback, and Bette Hagenstein at the homecoming parade in 1967. They became famous when the governor invited them to Cheyenne to sing Kerback's song, "Wyoming," as part of the state's 75th birthday celebration in 1965. (Courtesy of Paul and Bette Hagenstein.)

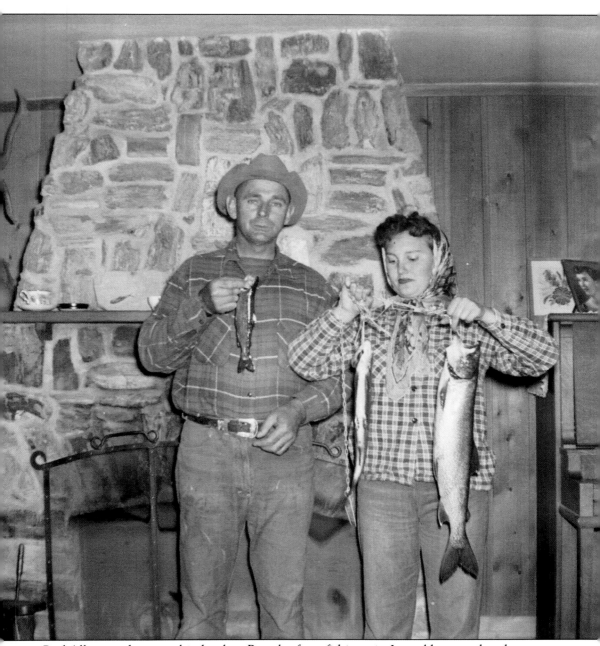

Paul Allen stands next to his daughter Beverly after a fishing trip. It would appear that the young lady was more successful than her father! A lifetime Pinedale resident, Allen left a historical photographic legacy by recording current events and re-photographing old-timers' picture collections. (Courtesy of Paul Allen.)

When the State Bank of Pinedale closed on December 31, 1934, Pinedale was left without a bank for decades. By the early 1960s, a strong area economy was sustaining the small community, so locals made an effort to establish a bank in Pinedale again. The new bank would be known as the First National Bank of Pinedale, pictured here as it appeared in the 1960s. (Courtesy of First National Bank of Pinedale.)

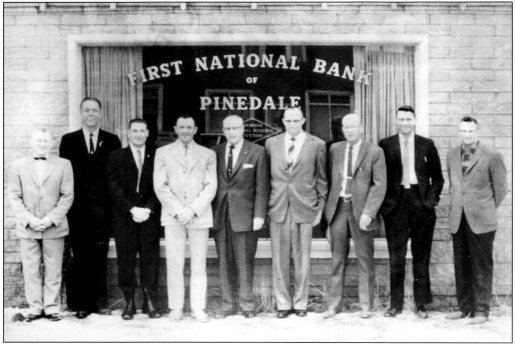

Opening-day ceremonies for the First National Bank of Pinedale were held on April 4, 1963, at 210 West Pine Street. Attending the festivities are, from left to right, Beryl Fullerton, Cecil Shaw, Vernon T. Delgado, Joe Hicks, Ross Copenhaver, Harvey Taylor, George Mill, Robert W. Sievers, and Charlie Fisher. All of these gentlemen were on the bank's board of directors, except for Wyoming state treasurer Copenhaver and state superintendent of public instruction Shaw. (Courtesy of First National Bank of Pinedale.)

Town locals take a break from their work for a photograph in the 1960s. The well-known men are, from left to right, Whitey Kape, Ted Weideranders, Bill Williams, and Charlie McAlister. The pine trees in the background line Pine Creek, which runs through town. (Courtesy of Ralph and Charlotte Faler.)

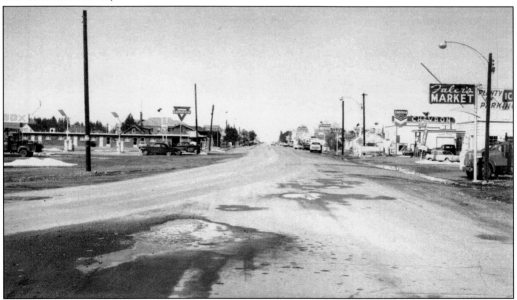

This 1960s view of Pine Street is looking west from the junction of Pine Street and Fremont Lake Road. Town businesses had expanded to this end of town by this time. Harold Faler opened his new IGA supermarket in March 1961 on the north side of Pine Street, while the Sundance Motel, pictured on the left, was constructed on the southwest corner of Pine Street and Sublette Avenue. (Courtesy of Sublette County Historical Society.)

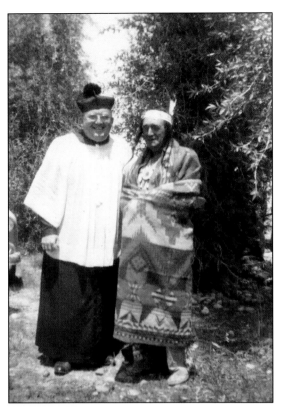

Fr. Charles Bartek (left) stands with Harry Warinner in the July 1956 Rendezvous reenactment. Father Bartek, the local Catholic priest, played Fr. Pierre Jean De Smet for many years in the Rendezvous. Warinner portrayed a Shoshone Native American. (Courtesy of Sublette County Historical Society.)

The Rendezvous reenactments were put on hold during World War II, but after the war, they came back to bigger crowds than before. To accommodate the spectators, reenactment planners moved the event to the rodeo grounds in Pinedale. Photographed here is the show at the rodeo grounds in 1960. (Courtesy of Sublette County Historical Society.)

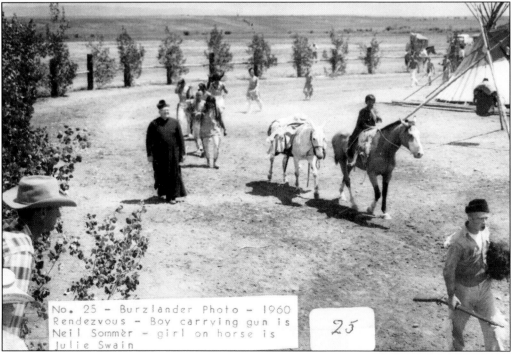

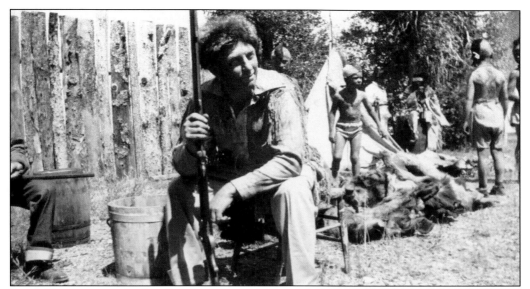

James Harrower was the first Rendezvous reenactment director and held the job for decades. He used a script written by Mary A. Scott. Harrower, photographed here, also played the part of fur trader Robert Campbell in the show. (Courtesy of Sublette County Historical Society.)

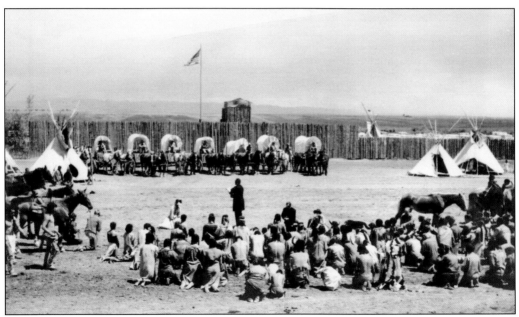

This 1960s photograph of the Rendezvous reenactment indicates the size and number of participants. Many townspeople took part in the event and so did several ranch families from surrounding communities. Dozens of horses and numerous wagons were also pressed into service for the impressive celebration of the height of the mountain-man era. (Courtesy of Sublette County Historical Society.)

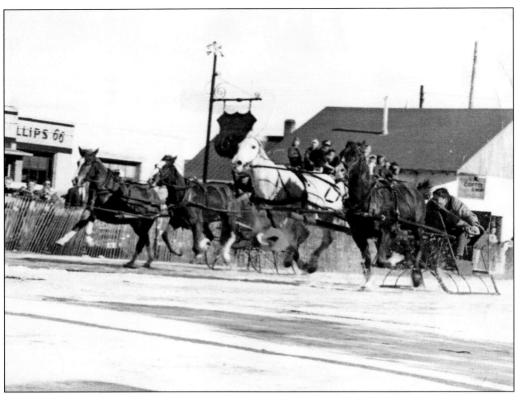

It was common for the town to close Pine Street in the wintertime in order to run cutter races. The cutters were often steel barrels attached to iron runners pulled by two horses. Cutter-racing competition was fierce among locals and area ranchers throughout the 1950s and 1960s. Above, Albert "Sunny" Korfanta is keeping tabs on the competition as he whips his team. Below, a Mr. Farwell and a Mr. Wilson vie against each other for the lead. (Both, courtesy of Albert "Sunny" and Fanny Korfanta.)

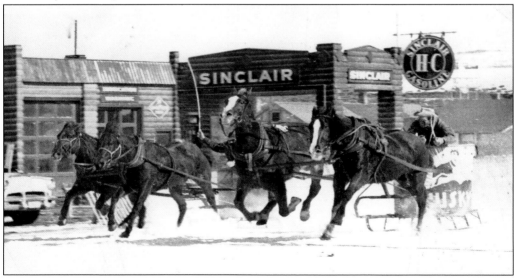

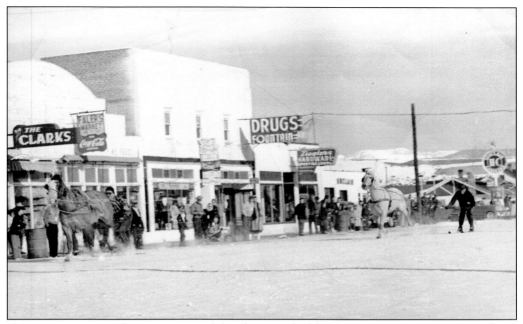

Ski-joring was a popular sport in Pinedale. Photographed here are two competitors racing down Pine Street during Pinedale's winter carnival in the 1950s. Skiers were pulled behind horses in the race to be the fastest. Albert "Sunny" Korfanta, the town's pharmacist, is the racer on the right behind the Palomino horse. (Courtesy of Albert "Sunny" and Fanny Korfanta.)

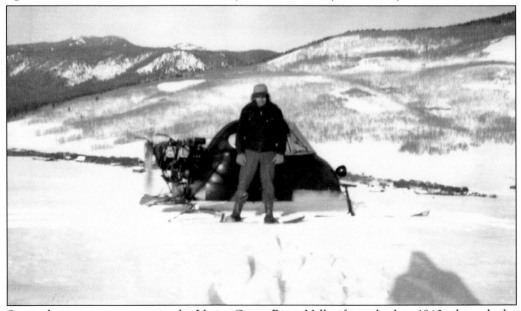

Snow planes were common in the Upper Green River Valley from the late 1940s through the early 1960s. Mike Noble stands in front of his snow plane in this picture. During the winter of 1951–1952, Noble courted Ruth Phillips, a schoolteacher in an isolated ranch on Willow Creek, using his snow plane. Snow planes were replaced in the late 1960s with the more reliable and versatile snowmobiles. (Courtesy of Mike and Ruth Noble.)

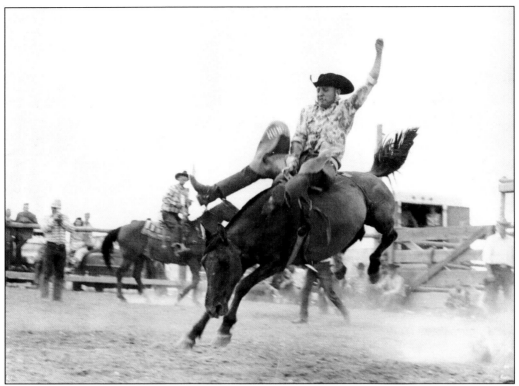

Harv Atwood was photographed here riding bareback on a bucking bronco in a Pinedale rodeo in the 1960s. Note the cigarette in his mouth. The ride does not appear to be hindering his ability to smoke! (Courtesy of Paul Allen.)

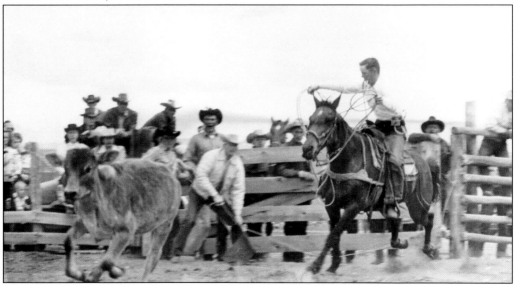

Bob Penton was showing off his roping ability in this photograph at a Pinedale rodeo in 1956. From his horse, he is attempting to rope a calf at full run. Penton was usually successful at his rodeo work. (Courtesy of Paul Allen.)

Identical signs with messages on the front and the back were placed at each end of town in 1963. A photograph caption in the April 11, 1963, *Pinedale Roundup* noted wryly, "visitors to Pinedale should now be well informed as to what town they are about to enter. . . . These very attractive signs will no doubt be very impressive to strangers and will cause some to remember Pinedale as the town with the big log signs. . . . Congratulations City Fathers!" The signs were constructed by the Town of Pinedale under the direction of Mayor Jim Harrower, and the State Highway Department helped install them. (Both, courtesy of Paul Allen.)

INDEX

DISCOVER THOUSANDS OF LOCAL HISTORY BOOKS
FEATURING MILLIONS OF VINTAGE IMAGES

Arcadia Publishing, the leading local history publisher in the United States, is committed to making history accessible and meaningful through publishing books that celebrate and preserve the heritage of America's people and places.

Find more books like this at
www.arcadiapublishing.com

Search for your hometown history, your old stomping grounds, and even your favorite sports team.

Consistent with our mission to preserve history on a local level, this book was printed in South Carolina on American-made paper and manufactured entirely in the United States. Products carrying the accredited Forest Stewardship Council (FSC) label are printed on 100 percent FSC-certified paper.

MADE IN THE

USA